GREAT MOMENTS IN
GAELIC
FOOTBALL

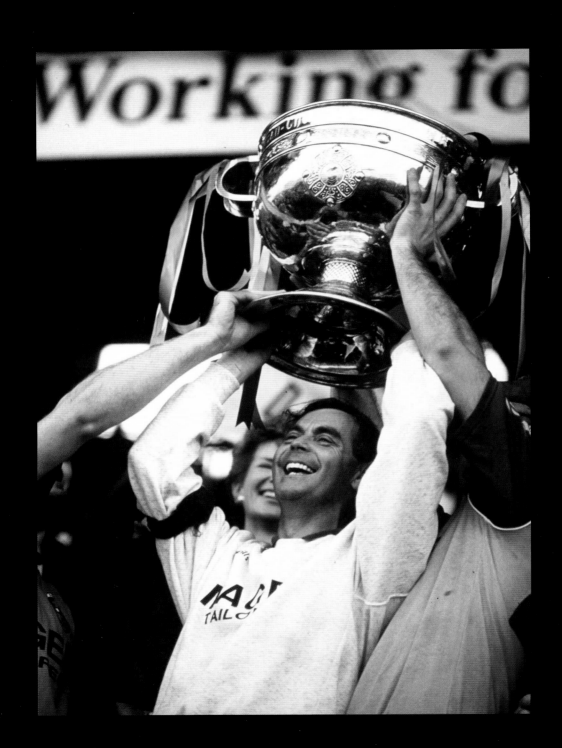

GREAT MOMENTS IN
GAELIC
FOOTBALL

from SPORTSFILE

THE O'BRIEN PRESS
DUBLIN

First published 2016 by The O'Brien Press Ltd,
12 Terenure Road East, Rathgar, Dublin 6, D06 HD27, Ireland.
Tel: +353 1 4923333; Fax: +353 1 4922777
E-mail: books@obrien.ie
Website: www.obrien.ie
The O'Brien Press is a member of Publishing Ireland.

ISBN: 978-1-84717-884-8

10 9 8 7 6 5 4 3 2 1
20 19 18 17 16

Layout and design: The O'Brien Press Ltd.
Printed and bound in Poland by Białostockie Zakłady Graficzne S.A.
The paper in this book is produced using pulp from managed forests.

Published in:

DUBLIN
UNESCO
City of Literature

CONTENTS

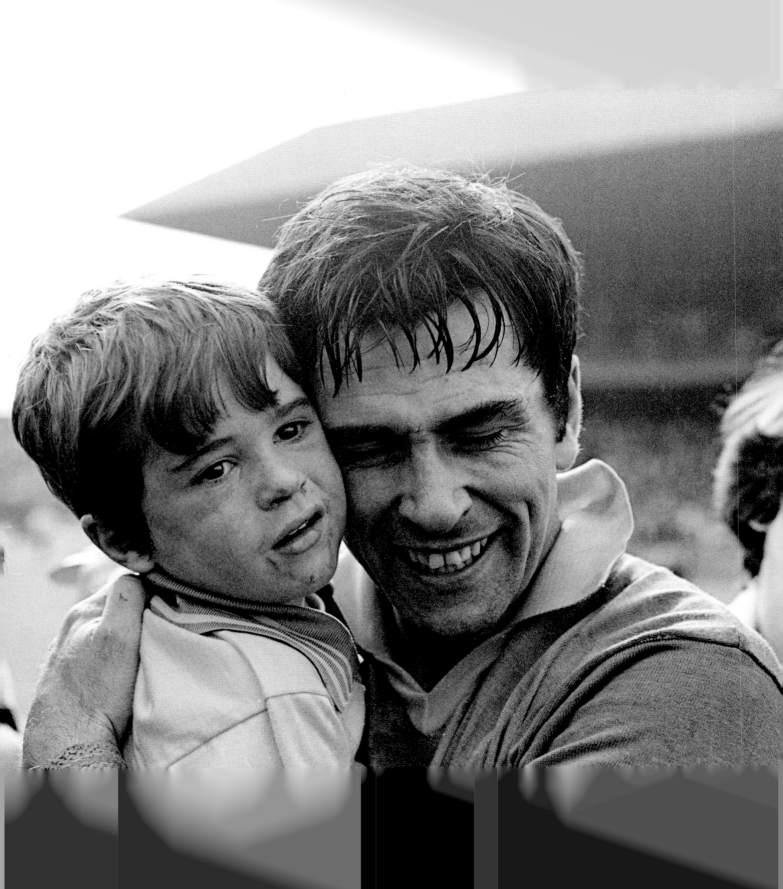

INTRODUCTION

It was August 1993, Derry had just beaten Dublin to qualify for the All-Ireland football final for only the second time in their history and I vividly remember capturing their manager, the late Eamonn Coleman, running on to the pitch to celebrate wildly with his team in front of the old Hogan Stand – a picture-perfect moment.

There have been many such moments in my thirty-plus years as a professional photographer and the access I've had to both private times and public celebrations with GAA sportsmen and women has made my job extremely rewarding.

I set up Sportsfile in the 1980s as a way to combine my love of photography and sport, and we filled a niche for top-class, up-to-the-minute images. Over the years we have expanded and, by insisting on the highest standards, have become an award-winning professional agency.

Looking through the images in this book I'm proud to see what an amazing resource our back catalogue has become. It chronicles the highs and lows of Gaelic games, captures the frenetic action, the quiet moments and the changing times.

I'm lucky to have a team of wonderful photographers who live and breathe sport; the images here are a testament to their talents, both technical and artistic.

Photography and sports are my passion as well as my job, and that's why you'll still find me in Parnell Park or Dr Hyde Park or Croke Park on any given Sunday. I hope these photographs convey the atmosphere of the great GAA occasions.

Ray McManus 2016

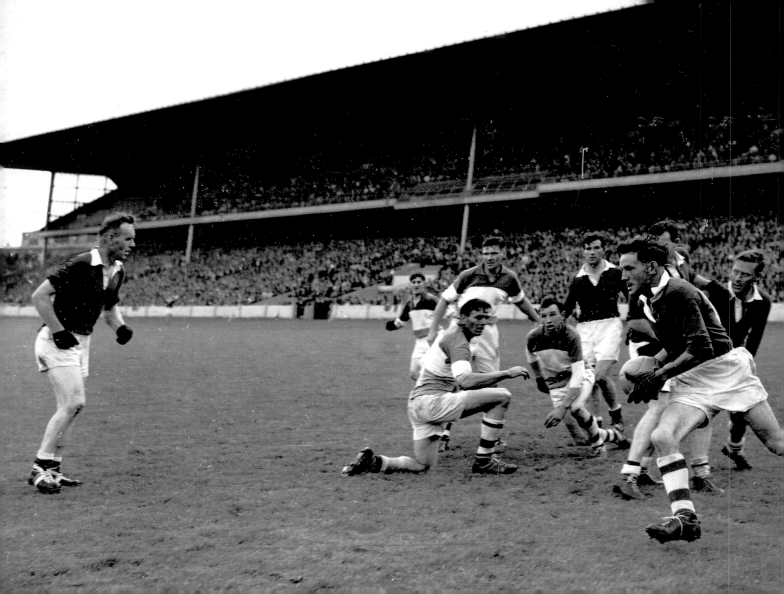

Ollie Ryan, Louth, flies past the Offaly challengers to pass the ball to Stephen White. A 0-10 to 1-6 victory for the Faithful county would clinch their first ever provincial title. Leinster Senior Football Championship Final, Offaly v Louth, Croke Park.

1960s

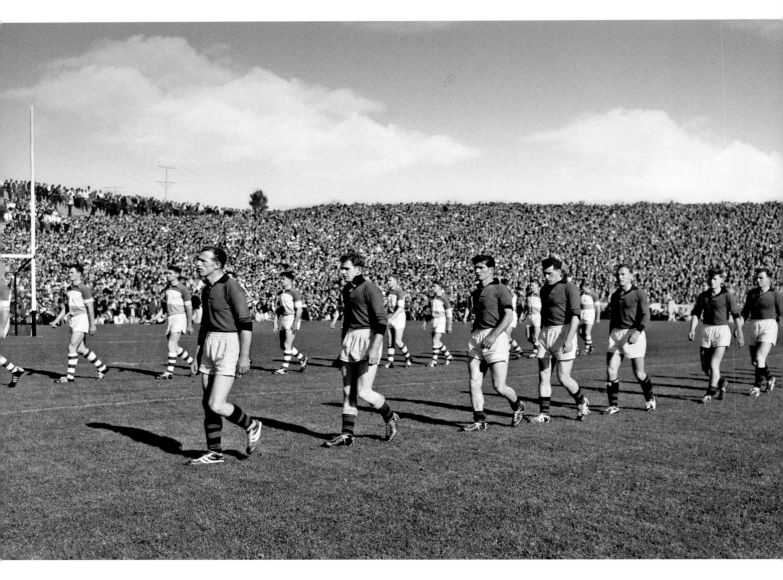

1961

The Down and Offaly teams during the pre-match parade in front of a huge crowd of 90,556 – the biggest ever to attend a GAA match in Croke Park. All-Ireland Senior Football Championship Final, Offaly v Down, Croke Park.

Connolly Collection / SPORTSFILE

1961

Offaly players leap skyward in the All-Ireland Senior Championship Final, Offaly v Down, Croke Park. Down beat Offaly in the final by 3-6 to 2-8 to retain their title.

Connolly Collection / SPORTSFILE

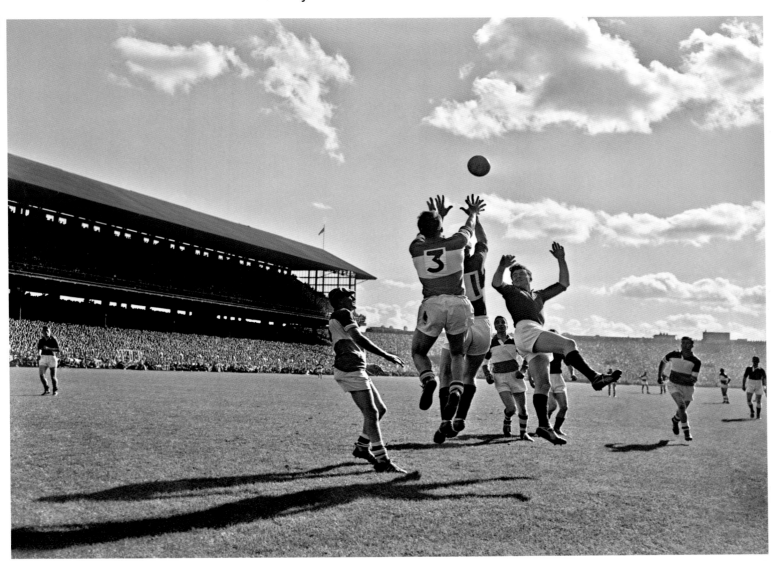

1965

Galway on their way to beating Kerry and retaining their All-Ireland
senior title at Croke Park.

Connolly Collection / SPORTSFILE

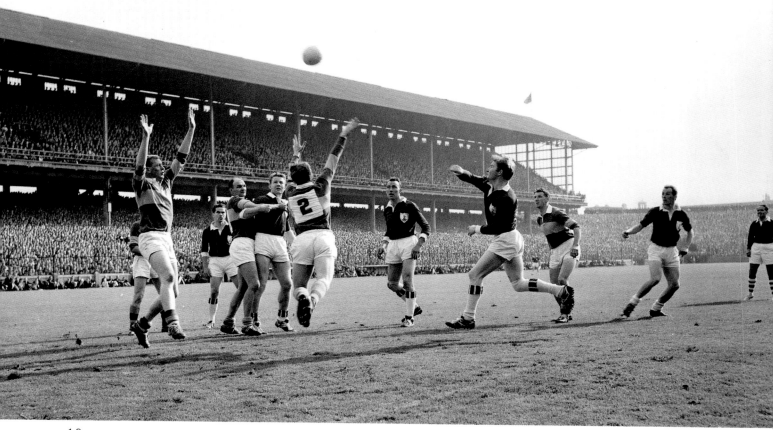

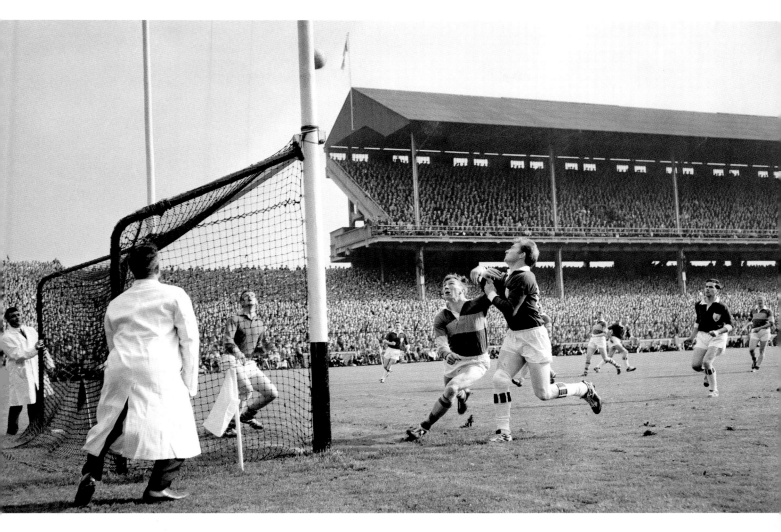

1965

A tense moment as players and umpires keep their eyes on the ball in the 1965 All-Ireland final in which Galway beat Kerry 0-12 to 0-9.

Connolly Collection / SPORTSFILE

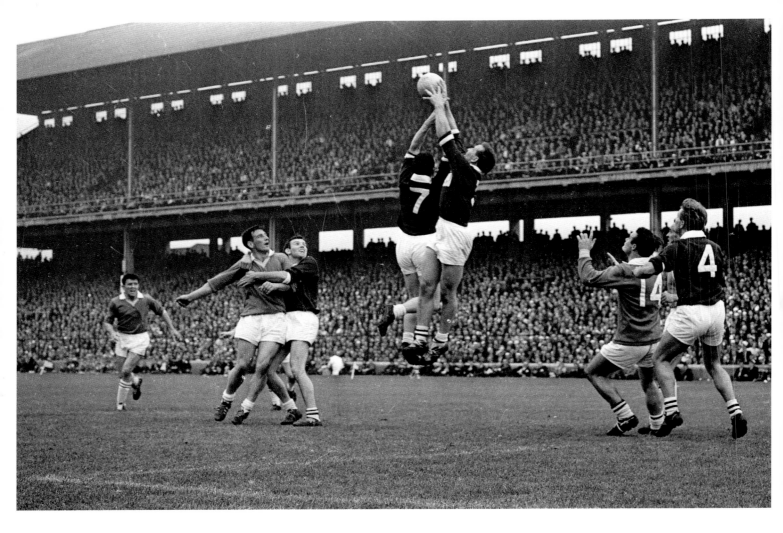

1966

Noel Tierney, right, and Martin Newell, Galway, take flight. All-Ireland
Senior Football Final, Galway v Meath. Croke Park.

Connolly Collection / SPORTSFILE

1966

All-Ireland Senior Football Final, Galway v Meath. Croke Park. Galway's six-point victory in the match secured the Tribesman their third All-Ireland title in a row. While Down also won three All-Ireland titles in the sixties Galway were the only county to complete the hat-trick. It's said that this match inspired Harry Beitzel, the Australian who developed International Rules football; in 1967, he sent an Australian side 'The Galahs' to play against an Irish side.

Connolly Collection / SPORTSFILE

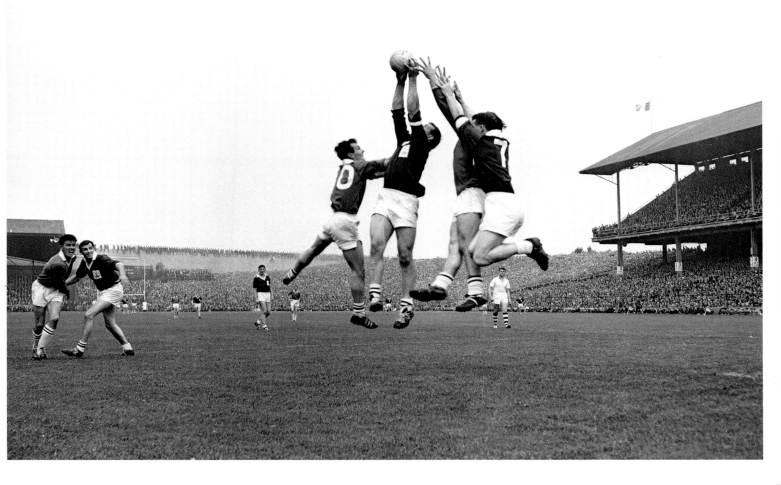

1966

Galway and Meath players line up to kiss the bishop's ring before the All-Ireland senior football final in Croke Park.

Connolly Collection / SPORTSFILE

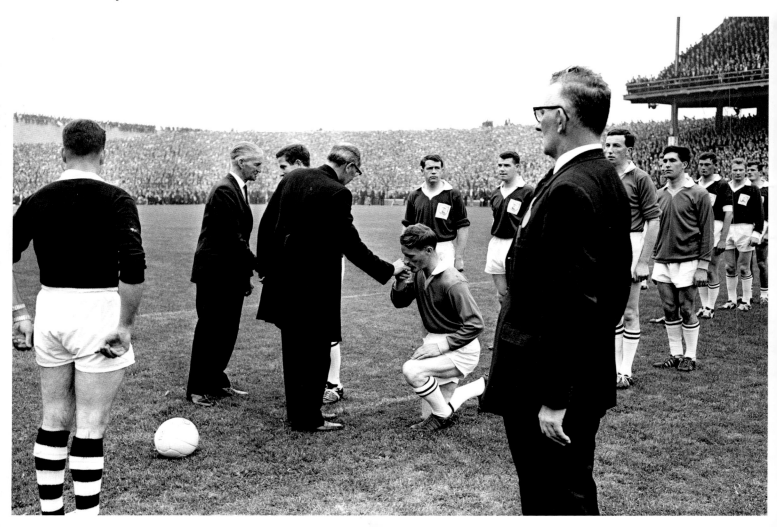

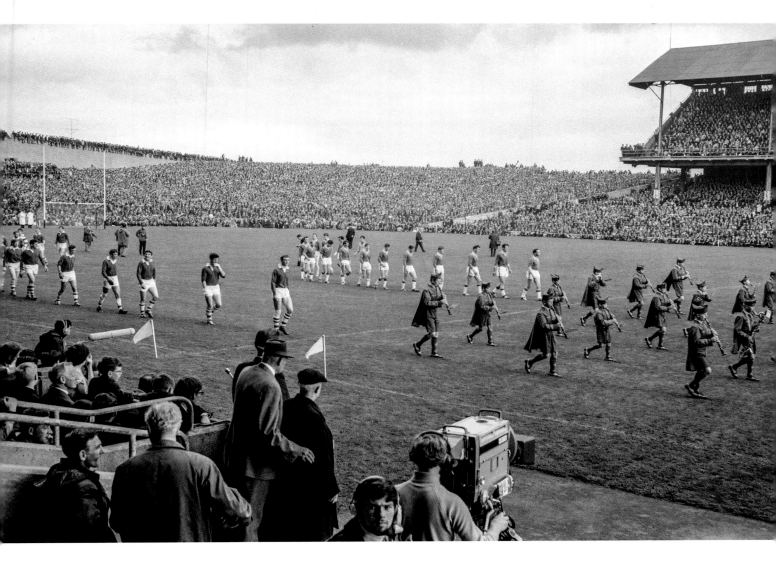

1967

The Cork and Meath teams led out by the Artane Boys' Band before the All-Ireland final. Note the television camera in the foreground; the first GAA match ever televised was the Kerry versus Dublin semi-final in 1962. This game was eventually won by Meath on a scoreline of 1-9 to 0-9.

Connolly Collection / SPORTSFILE

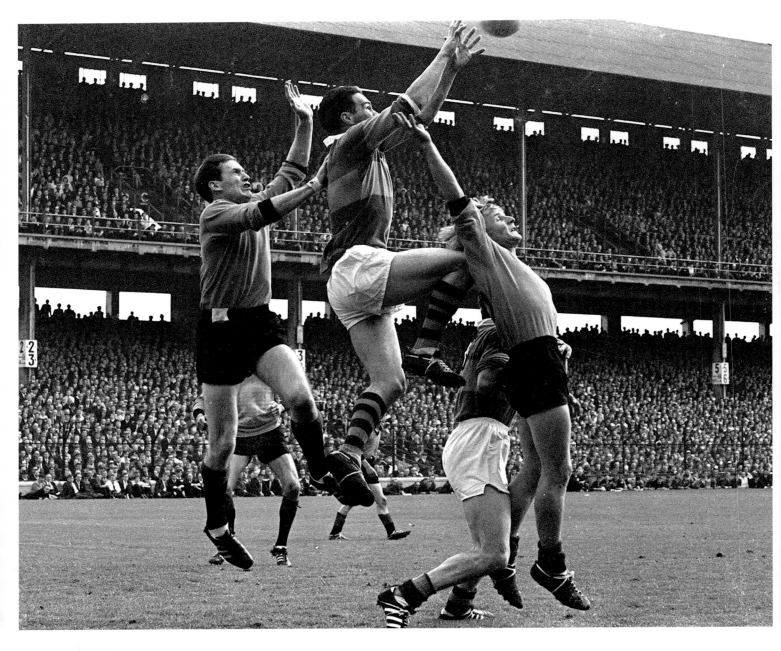

1968

Action from the 1968 All-Ireland final: Kerry's Mick O'Connell (centre) outfields Down's Sean O'Neill and John Purdy. O'Neill and John Murphy scored the goals as the Mournemen secured their third All-Ireland title in nine years and maintained their unbeaten championship record against Kerry.

Connolly Collection / SPORTSFILE

1968

Down fans prepare to invade the pitch to celebrate their team's
2-12 to 1-13 victory over Kerry in the All-Ireland final.

Connolly Collection / SPORTSFILE

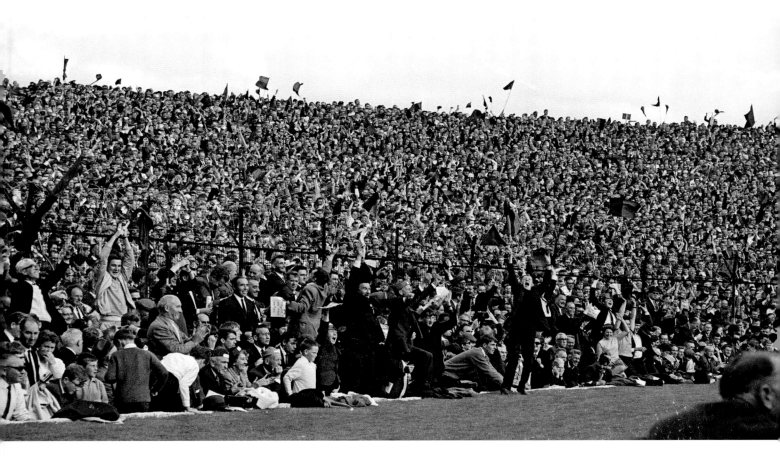

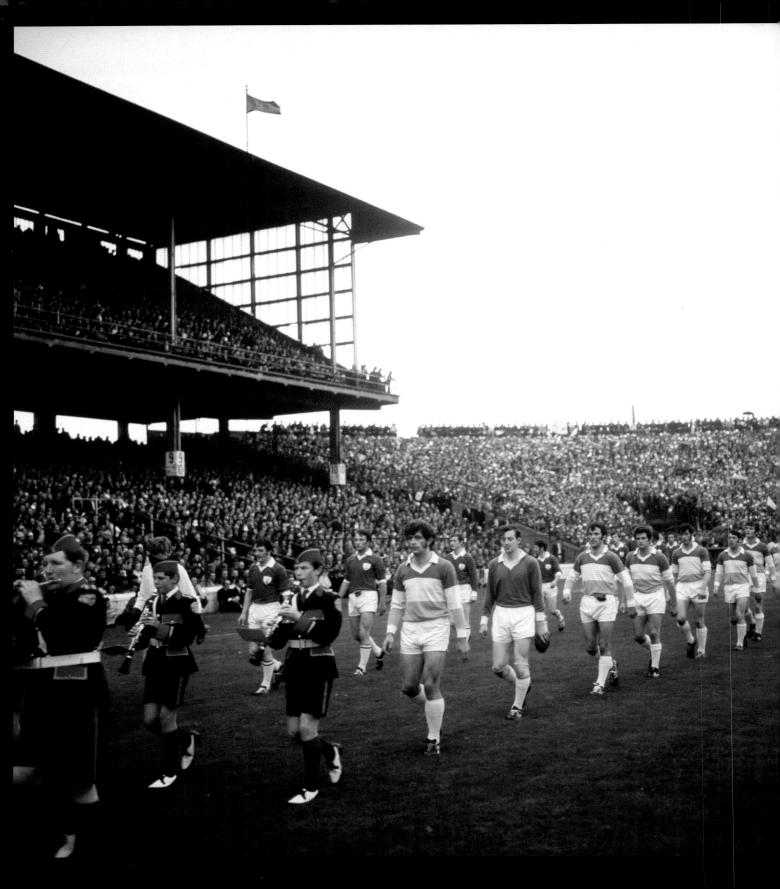

1971

The Offaly and Galway teams in glorious technicolour before the game. A goal from Murt Connolly gave Offaly their first All-Ireland title on a scoreline of 1-14 to 2-8.

1970s

1974

Dublin icon Kevin Heffernan who revived the fortunes of Dublin football, guiding them to three All-Ireland titles between 1974 and 1983. Pictured here during the 1974 All-Ireland semi-final in which Dublin scored a shock win over the defending All-Ireland title-holders Cork. As a player he was among the best in the business winning one All-Ireland medal, four Leinster and three National League medals.

Connolly Collection / SPORTSFILE

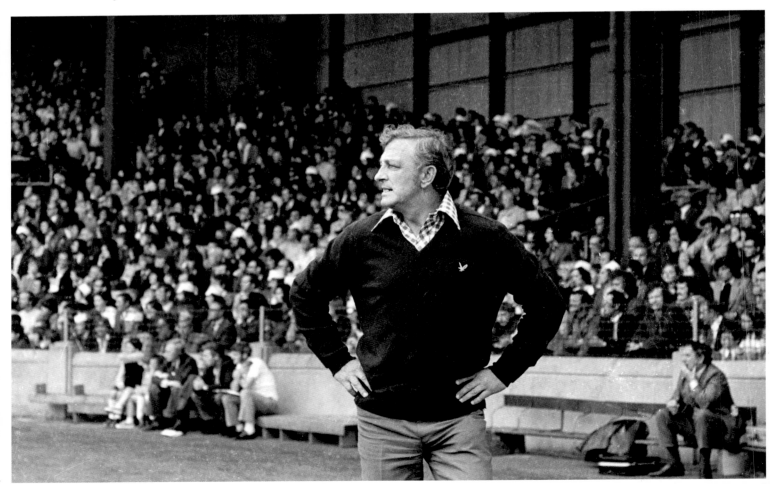

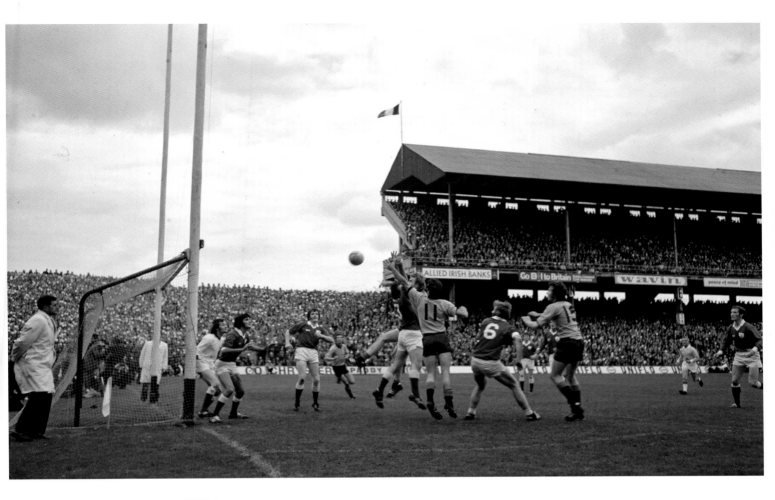

1974

The Galway defence comes under pressure in the 1974 All-Ireland final. Dublin, under the management of Kevin Heffernan, won the game 0-15 to 1-6 to secure their first All-Ireland title since 1963. Later that year Heffernan became the first non-player to win the Texaco Footballer of the Year award.

Connolly Collection / SPORTSFILE

1975

Kerry captain Mickey Ned O'Sullivan, left, shakes hands with Dublin captain Sean Doherty before the start of the 1975 All-Ireland final between Kerry and Dublin. By the time the final whistle sounded O'Sullivan was in the nearby Mater Hospital receiving treatment, having being knocked unconscious as he soloed through the Dublin defence. In his absence his team mate Pat Spillane received the Sam Maguire Cup.

Connolly Collection / SPORTSFILE

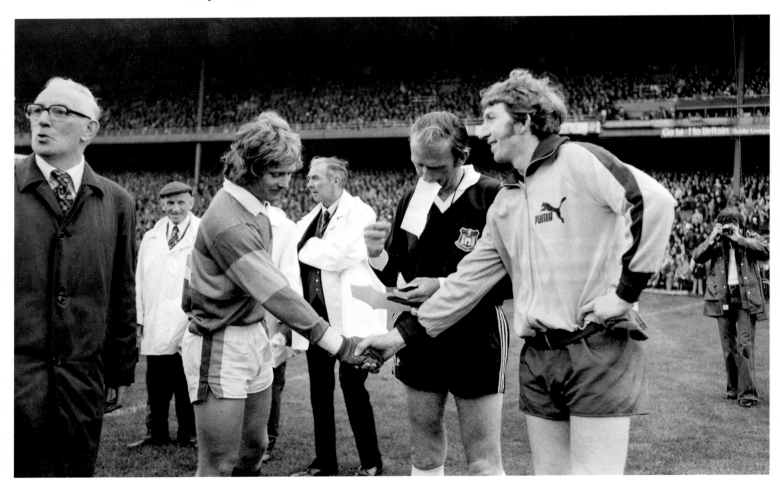

1977

Seán Walsh, Kerry, in action against midfield stalwart Brian Mullins, Dublin. Dublin triumphed this time, in what's often considered to be one of the greatest games ever played. All-Ireland Senior Football Championship Semi-Final, Dublin v Kerry, Croke Park.

Connolly Collection / SPORTSFILE

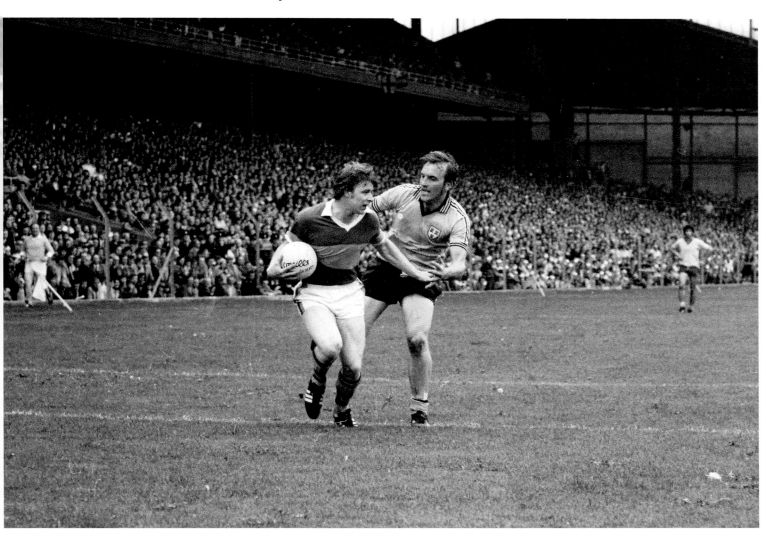

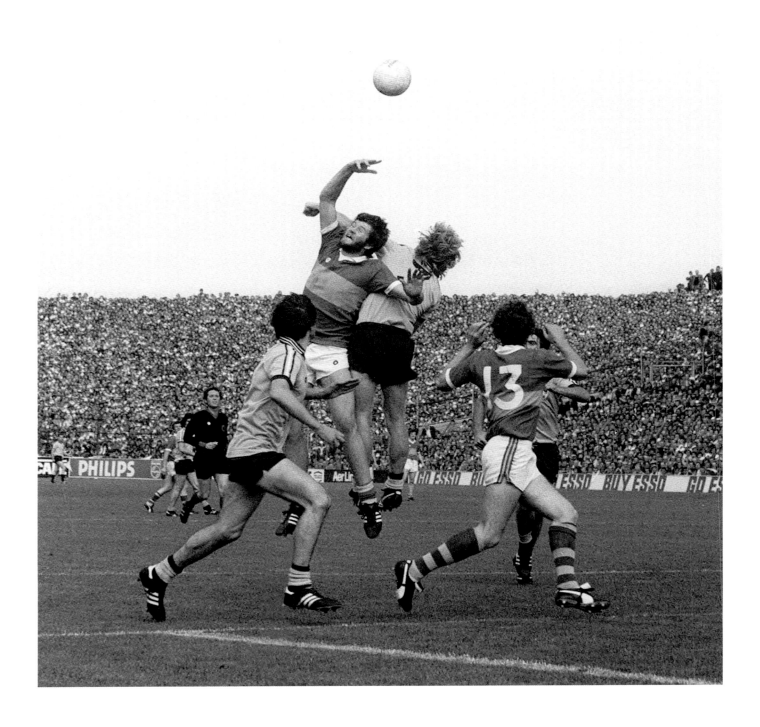

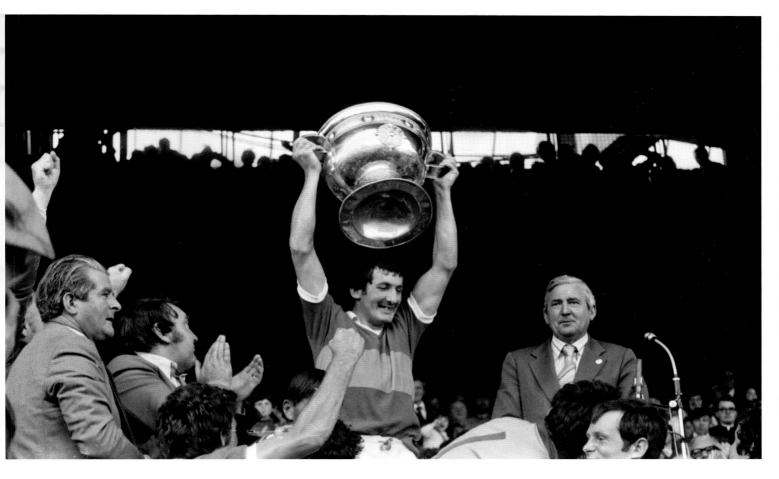

Opposite: 1979

Eoin 'Bomber' Liston, Kerry, in action against Mick Holden, Dublin, in the All-Ireland Football Final, Kerry v Dublin, Croke Park.

SPORTSFILE / Connolly Collection

Above: 1979

Kerry captain Tim Kennelly lifts the Sam Maguire Cup after Kerry's crushing 3-13 to 1-8 defeat of Dublin. The tough centre-back won five All-Ireland medals during his career. His sons Noel and Tadhg followed in their father's footsteps by winning All-Irelands in 2000 and 2009.

SPORTSFILE / Connolly Collection

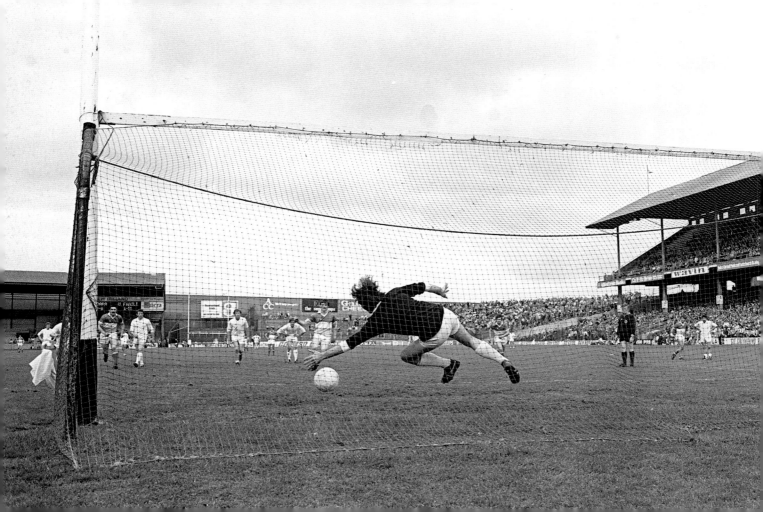

1980

Matt Connor, Offaly, drives a penalty past Kildare goalkeeper Ollie Crinnigan during the Leinster Football Championship Semi Final, Croke Park. 1980 was the first year of Offaly's three-in-a-row of Leinster titles.

SPORTSFILE

1980s

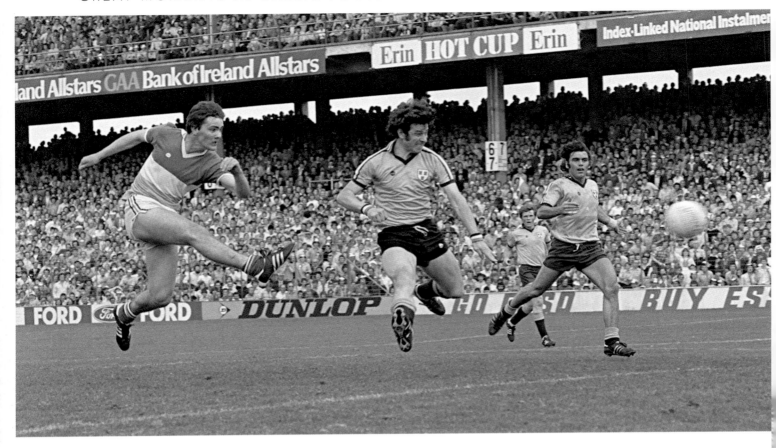

Above: 1980

Matt Connor, Offaly, shoots goalwards despite the attentions of Bernard Brogan, Dublin, in the Leinster Football Final, Croke Park. Connor, regarded as one of the best forwards of all time, featured on the Offaly team from 1978 to 1984. On Christmas Day 1984 he was seriously injured in a car crash, which ended his footballing career.

Ray McManus / SPORTSFILE

Opposite: 1980

Roscommon's Dermot Earley celebrates with his son David after victory over Armagh. All-Ireland Football Semi-Final, Roscommon v Armagh, Croke Park.

Ray McManus / SPORTSFILE

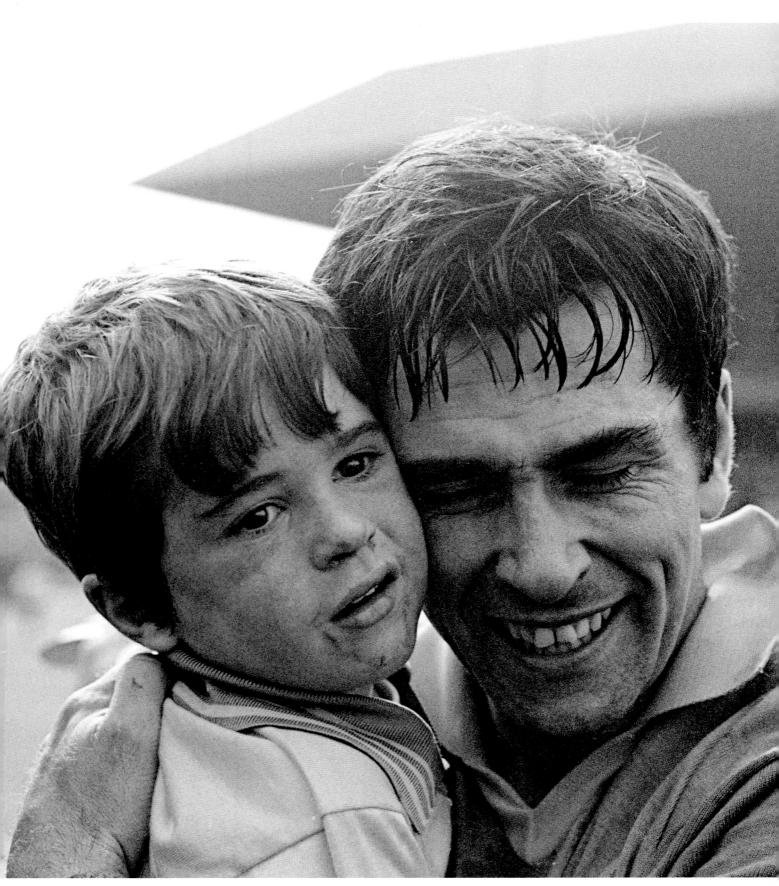

1980

Pat Spillane, Kerry, left, springs into action against Roscommon. Roscommon had finally made it to the final after three consecutive semi-final defeats, but an experienced Kerry side got the better of them, 1-09 to 1-06.

Ray McManus / SPORTSFILE

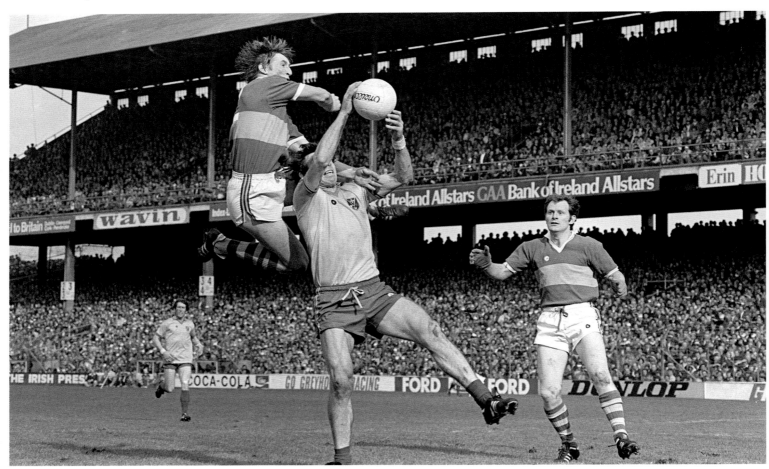

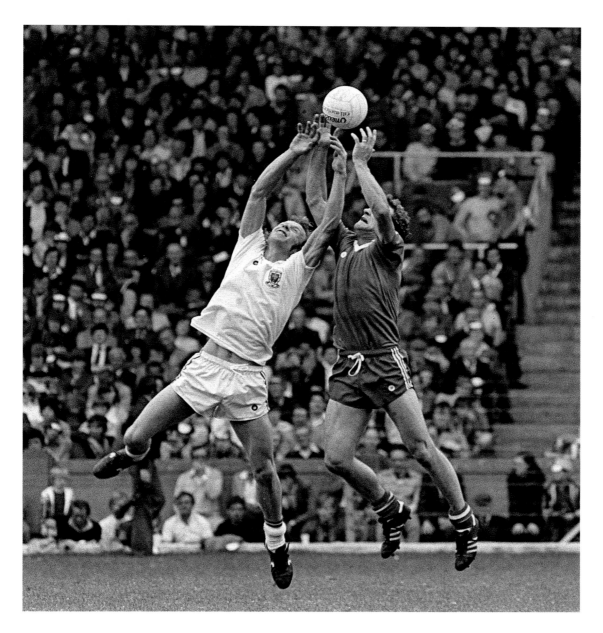

1981

Jimmy Lyons, Mayo, contests possession with Jack O'Shea, Kerry. All-Ireland Football semi-final, Kerry v Mayo, Croke Park. After twelve seasons where they failed to make it out of the Connacht championship, Mayo finally reached the 1981 All-Ireland semi-final, but endured a 2-19 to 1-6 loss against Kerry.

Ray McManus / SPORTSFILE

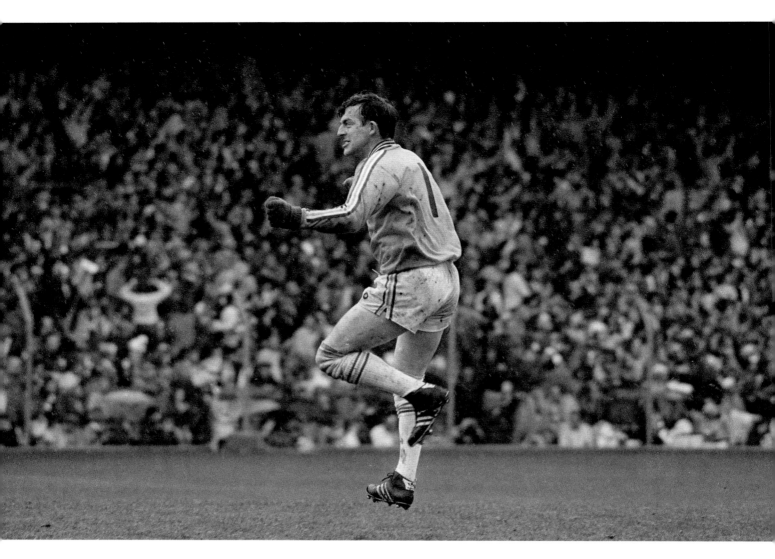

1982

Offaly goalkeeper Martin Furlong celebrates after Seamus Darby scored their side's last-gasp goal – which denied Kerry five All-Ireland Football titles in a row. All-Ireland Senior Football Final, Kerry v Offaly, Croke Park.

Ray McManus / SPORTSFILE

1983

Cork fans celebrate Tadhg Murphy's last-minute goal as Kerry goalkeeper Charlie Nelligan picks the ball out of the net with midfielder Jack O'Shea looking on. Kerry had been aiming for nine Munster titles in a row, and were leading by two points going into injury time before Murphy's winning goal, which gave the Rebels the title on a 3-10 to 3-9 scoreline. Munster Football Final, Cork v Kerry, Páirc Uí Chaoimh, Cork.

Ray McManus / SPORTSFILE

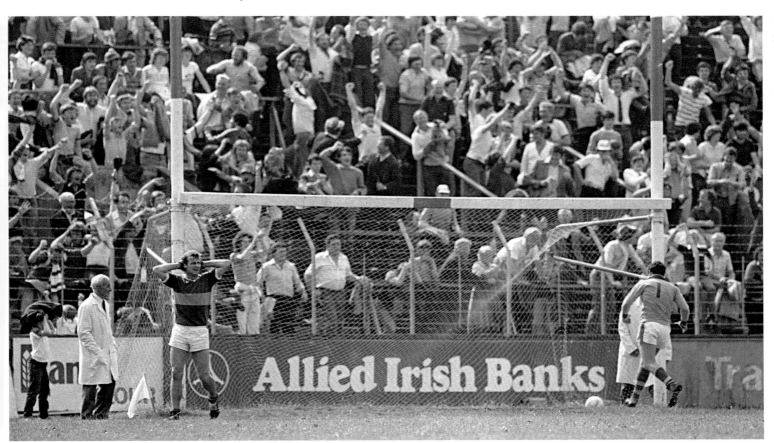

1983

Barney Rock, Dublin, contests a high ball with Cork goalkeeper Michael Creedon. All-Ireland Senior Football Championship Semi-Final Replay, Dublin v Cork, Páirc Uí Chaoimh, Cork. Dublin scored a win over defending All-Ireland title holders, Offaly in the Leinster final before Rock scored a dramatic equalising goal in Croke Park to draw the All-Ireland semi-final against Cork. Cork made a persuasive argument that Croke Park counted as a home game for Dublin, so the replay was held in Cork. But the Dubs had the last laugh!

Ray McManus / SPORTSFILE

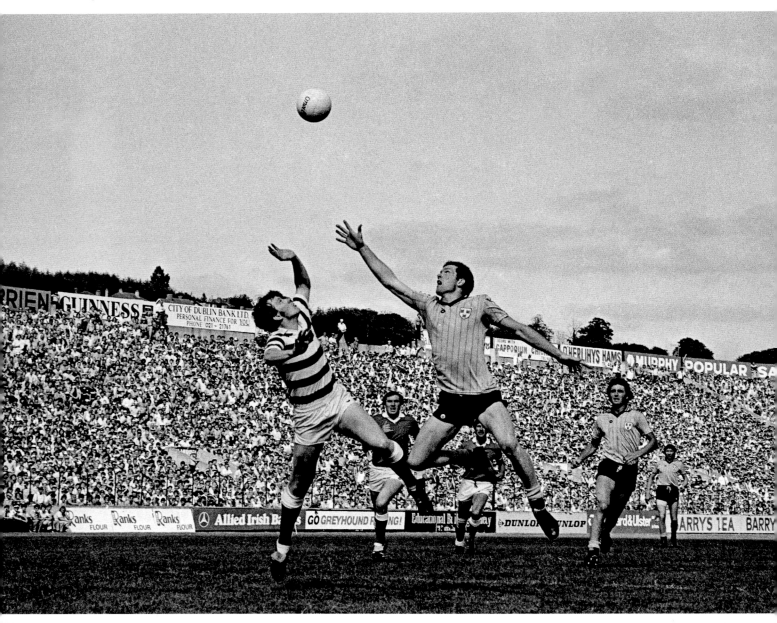

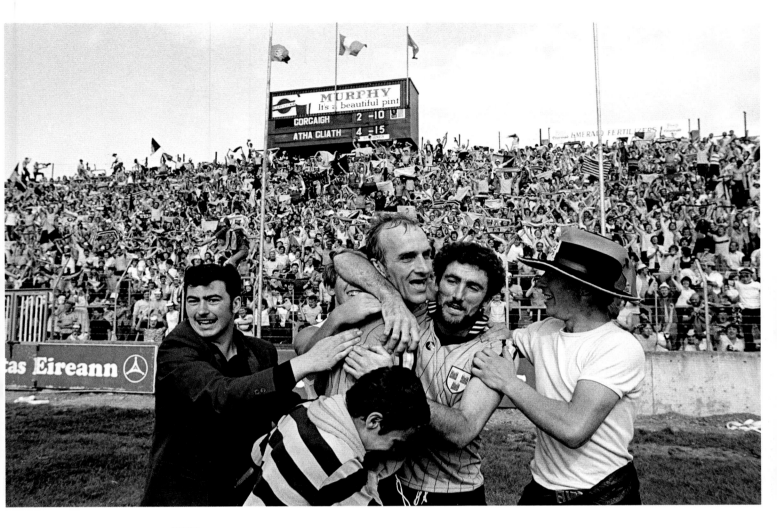

1983

Dublin's Brian Mullins, left, and team-mate Ciarán Duff celebrate Dublin's win over Cork with supporters in Páirc Uí Chaoimh after the final whistle. Thousands of Dub fans made the trip south for the match and celebrated in style afterwards on the pitch. All-Ireland Senior Football Championship Semi-Final Replay, Dublin v Cork, Páirc Uí Chaoimh, Cork.

Ray McManus / SPORTSFILE

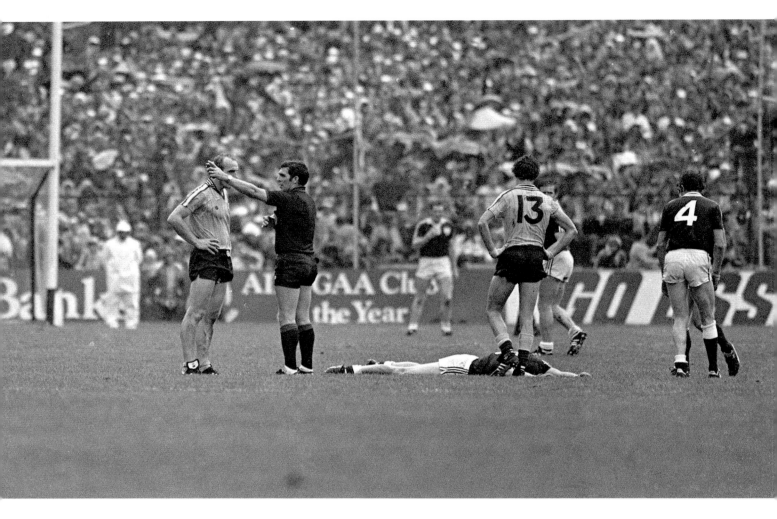

1983

Dublin's Brian Mullins is sent off by referee John Gough in the 1983
All-Ireland, which was one of the most controversial in the history of
the game. Three more players, Dublin's Ray Hazley and Ciaran Duff
and Tomás Tierney from Galway were also dismissed. In the end the
twelve-man Dublin team ('The Twelve Apostles') prevailed 1-10 to
1-08 over the fourteen-man Galway team.

Ray McManus / SPORTSFILE

1984

Tyrone legend, Frank McGuigan, whose performance in the 1984 Ulster Final went down in history: McGuigan scored eleven of Tyrone's fifteen points – five from each foot and one fisted over – as they beat Armagh. It was one of the greatest individual scoring performances in the history of Ulster finals.

Ray McManus / SPORTSFILE

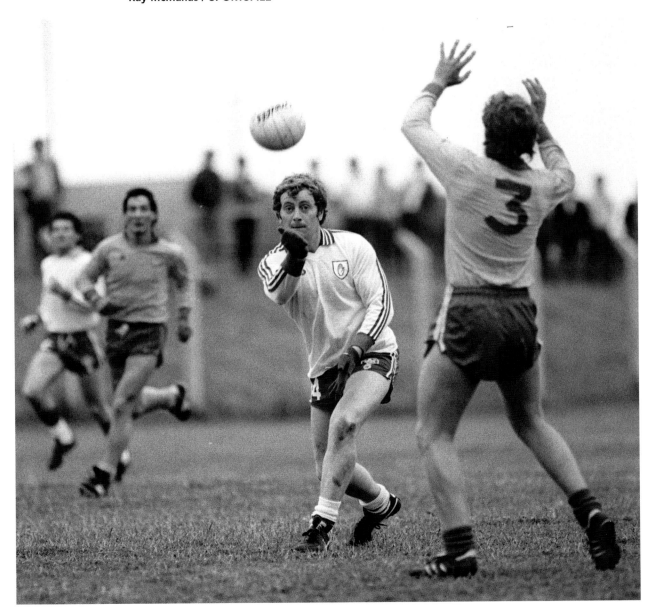

1984

Kerry captain Ambrose O'Donovan celebrates with the Sam Maguire Cup after his team's five-point victory, 0-14; 1-6, over Dublin in the All-Ireland Football Final.

Ray McManus / SPORTSFILE

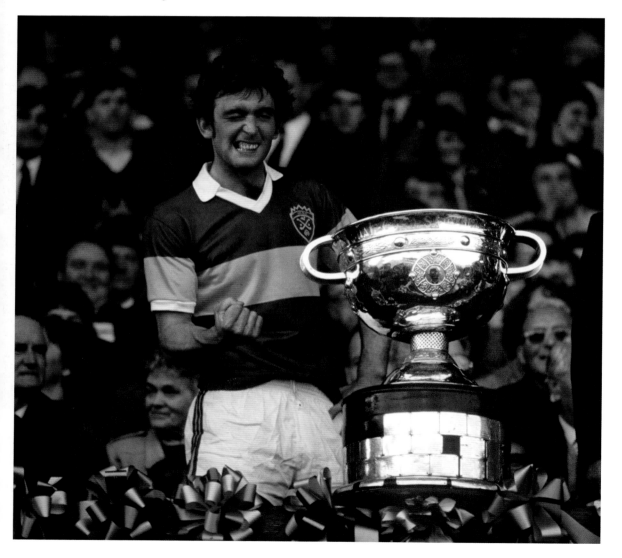

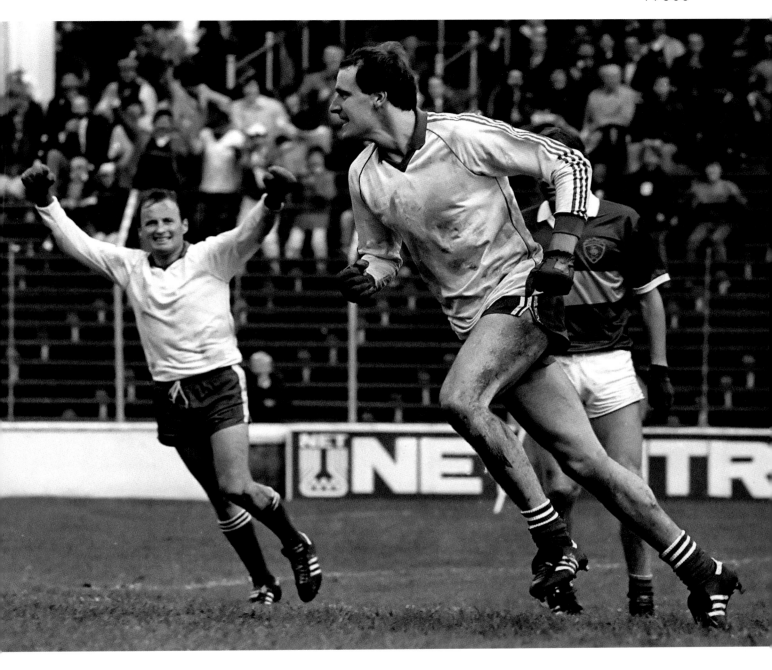

1985

Eamon Murphy, Monaghan, turns away after scoring a goal against Kerry in the 1985 All-Ireland Football semi-final as team mate 'Nudie' Hughes celebrates. This match ended in a draw, but Kerry won the replay 2-10 to 0-9 and advanced to the final.

Ray McManus / SPORTSFILE

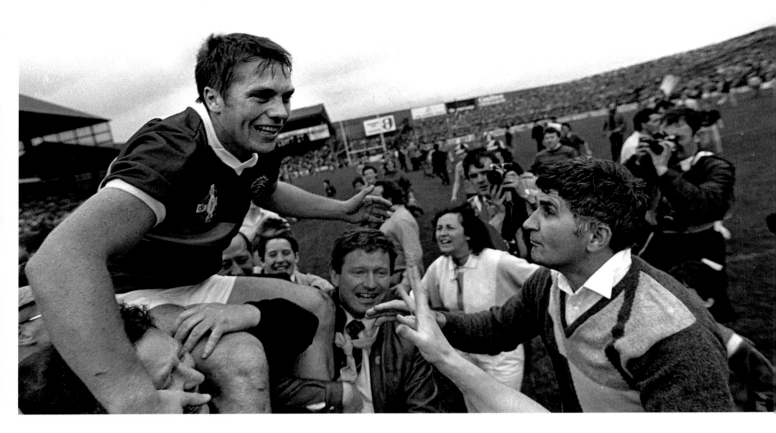

1985

Kerry captain Páidí O Sé is held aloft as manager Mick O'Dwyer, right, offers his congratulations after Kerry's 2-12 to 2-8 victory over Dublin. All-Ireland Football Final, Kerry v Dublin, Croke Park.

Ray McManus / SPORTSFILE

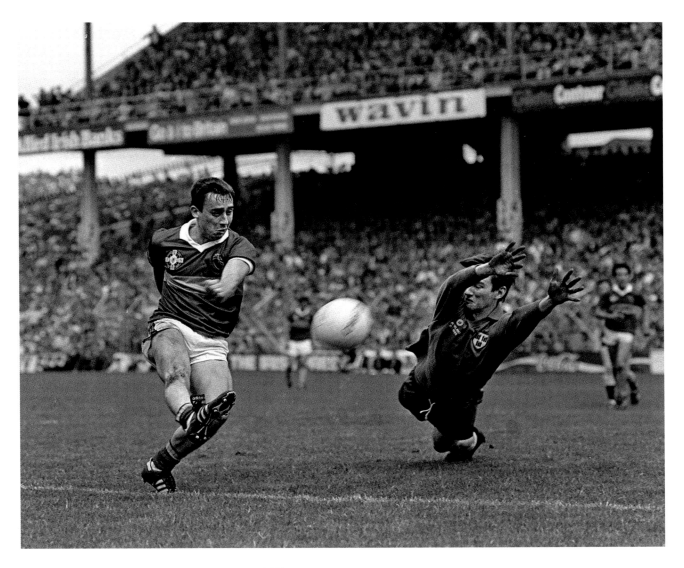

1985

Denis 'Ogie' Moran, Kerry, in action against John O'Leary, Dublin.
Kerry v Dublin, All-Ireland Football Final, Croke Park.

Ray McManus / SPORTSFILE

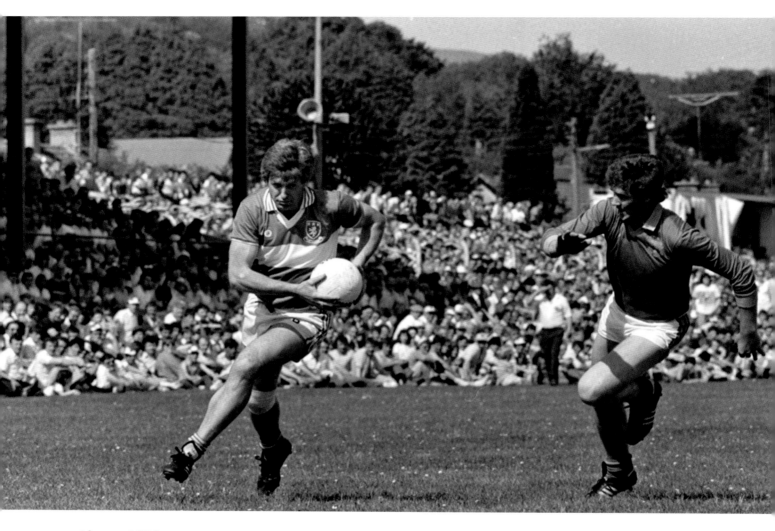

Above: 1986

The Battle of Aughrim. Defending League champions Laois suffer a shock 2-10 to 1-9 loss to Wicklow in the quarter final of the 1986 Leinster championships. County Park, Aughrim, Co. Wicklow.

Ray McManus / SPORTSFILE

Opposite: 1986

Meath manager Sean Boylan, left, celebrates his team's win with Liam Creavin (now deceased), the long serving secretary of the Meath GAA Board, after the county's win over Dublin in the 1986 Leinster final. It was Meath's first provincial title since 1967.

Ray McManus / SPORTSFILE

1987

Dublin's Barney Rock scores what proved to be the winning goal in extra time; the National Football League semi-final between Dublin and Cork had finished level, with Dublin 0-10 and Cork 1-07, so extra time was announced; Cork officials, however, pushed for a replay and refused to allow the Cork players back onto the pitch. So the referee and the Dublin team returned, and, in solitary splendour, the Dubs played on! Declan Bolger passed to Barney Rock, who scored into an empty net – Dublin 1-10, Cork 1-07.

Connolly Collection / SPORTSFILE

Below: 1987

Meath's David 'Jinksy' Beggy in action against Cork's Tony Nation, left, and Shay Fahy. All-Ireland Football Final, Meath v Cork, Croke Park. Beggy had come to GAA from a rugby background; he rose to prominence in 1986 and quickly became a fan favourite.

Ray McManus/SPORTSFILE

Opposite: 1987

Meath's goal-scorer Colm O'Rourke is carried shoulder high by Meath fans after his side's 1-14 to 0-11 victory over Cork in the 1987 All-Ireland Football Final.

Ray McManus/SPORTSFILE

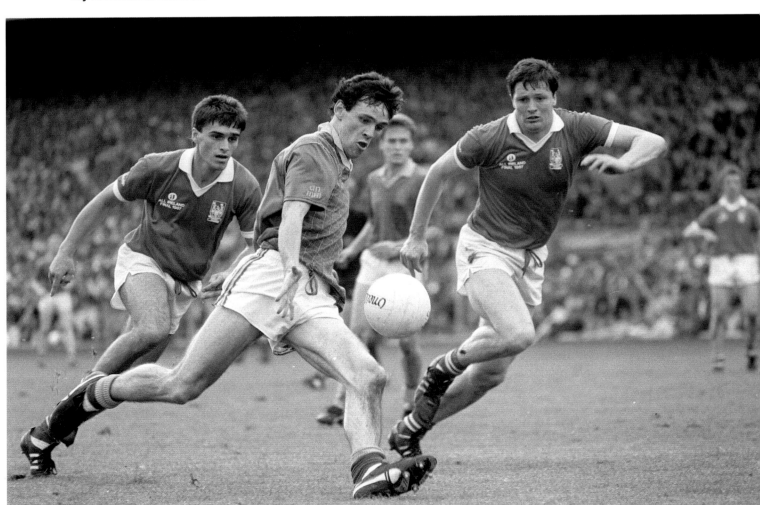

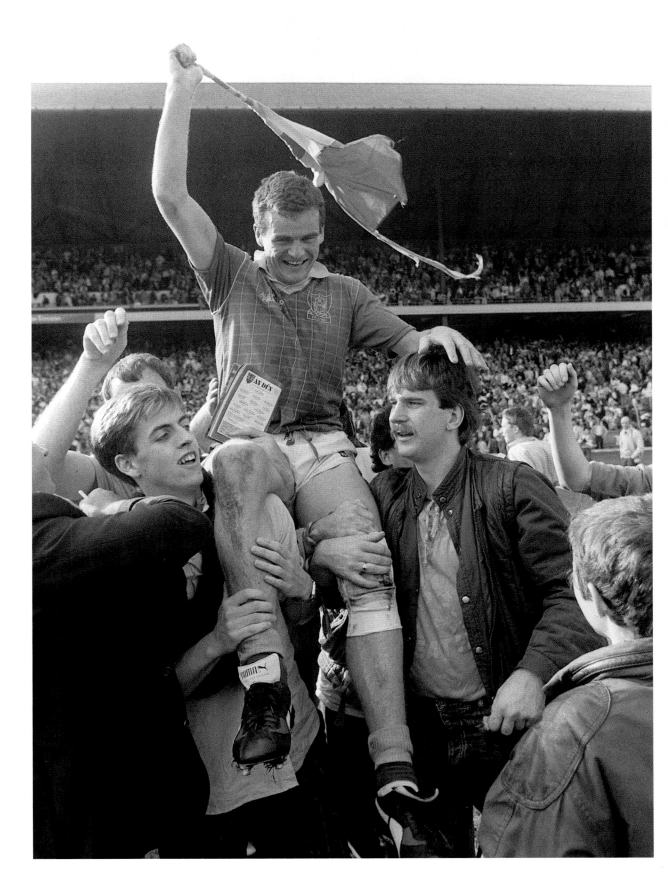

1989

Cork's Larry Tompkins, in a Dublin jersey, celebrates after his team's victory
over the Dubs in the 1989 National League Final, Croke Park.

Ray McManus / SPORTSFILE

1989

In the shadow of the magnificent Tomies Mountains, supporters from both sides watch the 1989 Munster final between Kerry and Cork in Killarney's Fitzgerald Stadium. The Rebels won 1-12 to 1-9 to capture a third successive provincial title.

SPORTSFILE

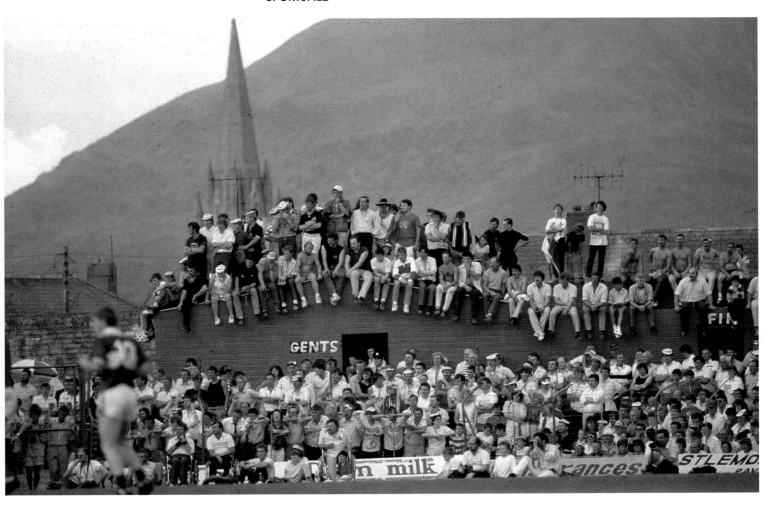

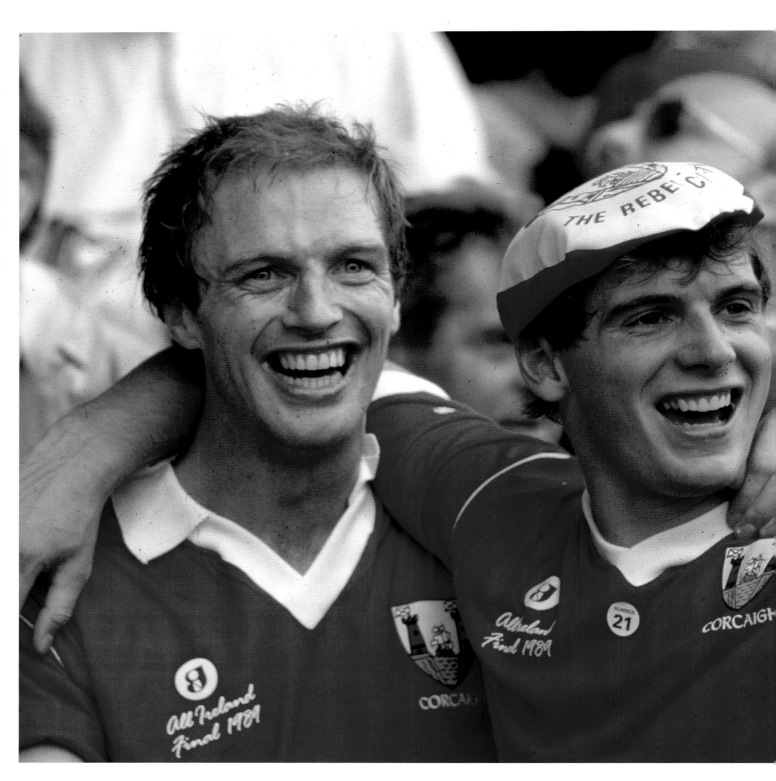

1989

Cork players, Larry Tompkins, left, and John O'Driscoll, celebrate on the steps of the Hogan Stand after the 1989 All-Ireland final in which Cork beat Mayo by three points (0-17; 1-11).

SPORTSFILE

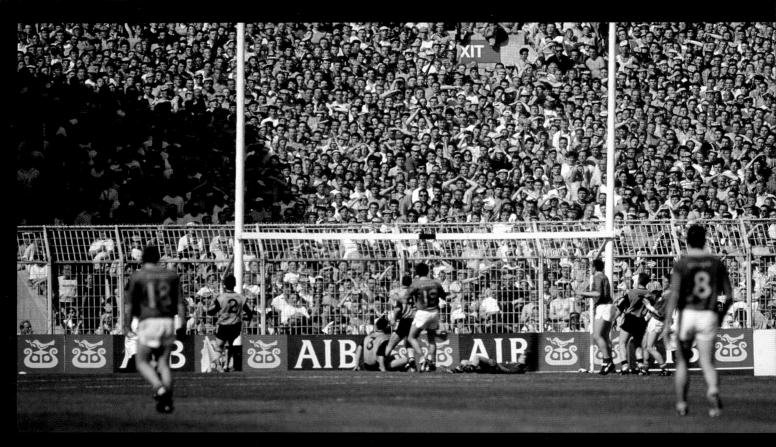

1991

Stunned Dublin fans on Hill 16 cannot believe their eyes as Kevin Foley scores a late, late goal for Meath to level the incredible four-match saga between the counties in the preliminary round of the 1991 Leinster Football Championship. This was the third replay between the counties and the contest was settled moments later when Meath's David Beggy hit the winning score for the Royals.

1990s

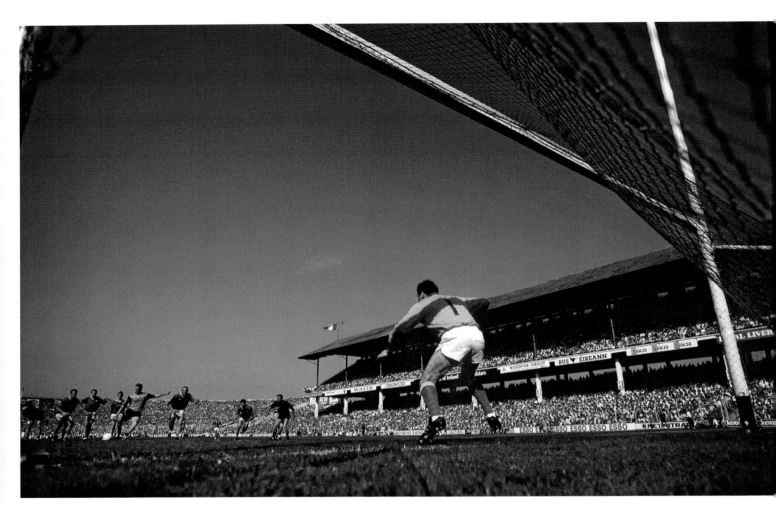

1991

Keith Barr, Dublin – with Meath's Mick Lyons in close attention –
drives a penalty wide against Michael McQuillan early in the third
replay. Dublin v Meath, Leinster Senior Football Championship, first
round, third replay, Croke Park.

Ray McManus / SPORTSFILE

1991

Down substitutes celebrate at the final whistle as Down beat Meath 1-16 to 1-14 in the All Ireland decider. Note photographer Cyril Byrne, then of the *Irish Press,* almost getting knocked over in the rush.

SPORTSFILE

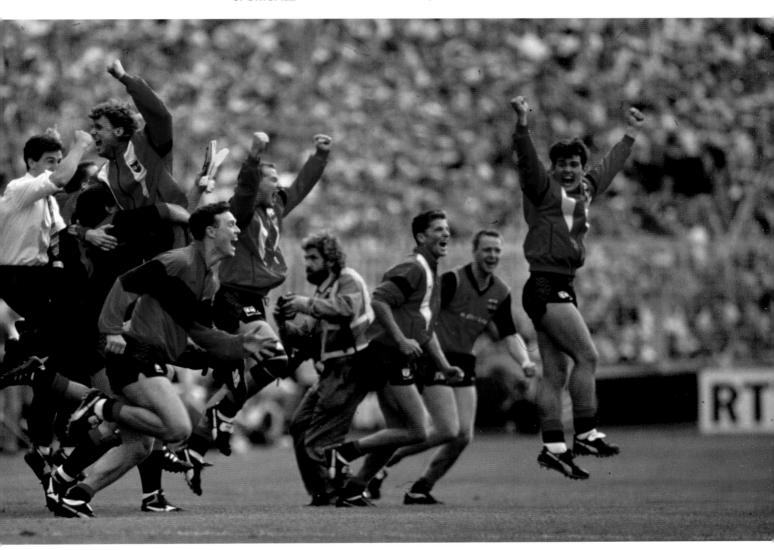

1991

DJ O'Kane, Down, celebrates at the end of the game. All Ireland
Football Final, Down v Meath, Croke Park.

Ray McManus / SPORTSFILE

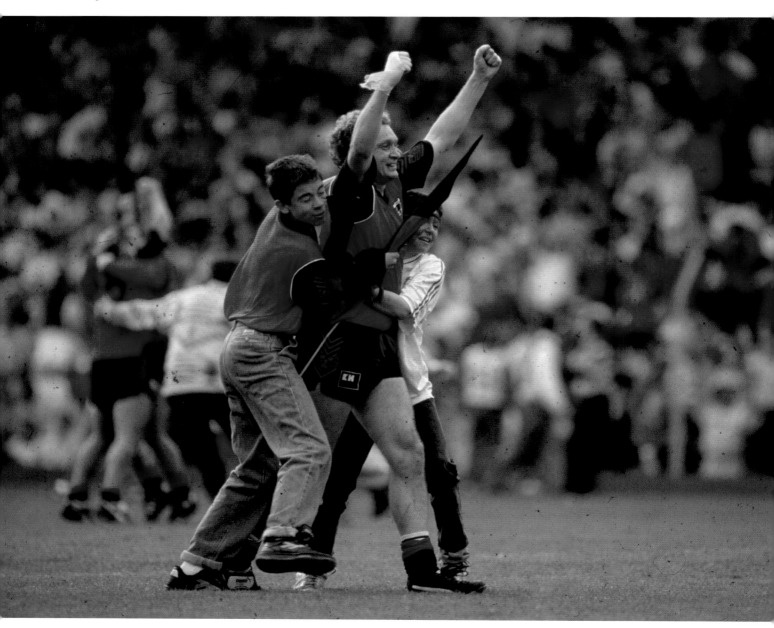

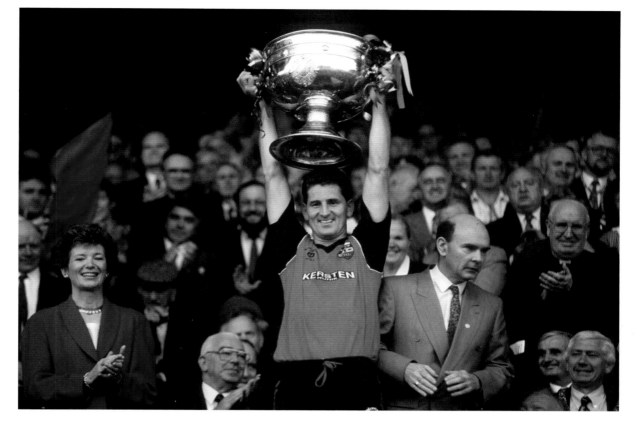

1991

Paddy O'Rourke, Down captain, flanked by President Mary Robinson and GAA President Peter Quinn, lifts the Sam Maguire Cup after his team defeated Meath, in the 1991 All Ireland Final, Croke Park,

Ray McManus / SPORTSFILE

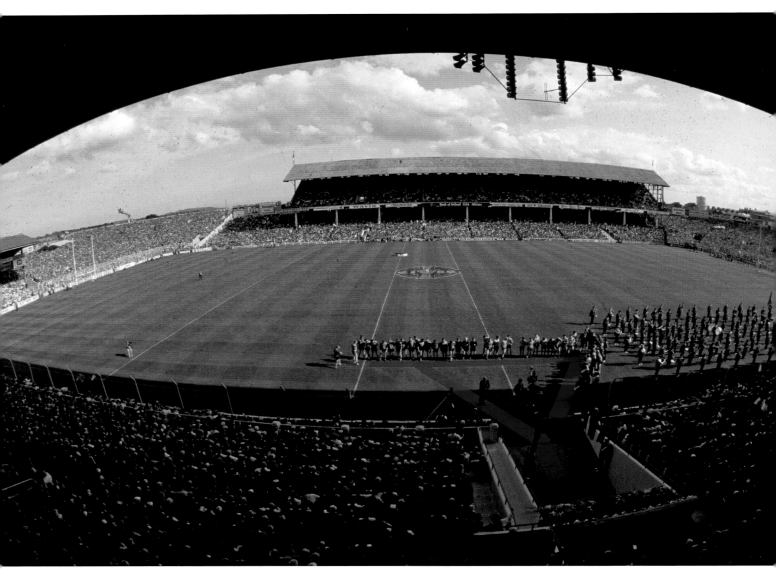

1992

A general view of Croke Park before the game. All-Ireland Senior
Football Championship Final, Dublin v Donegal Croke Park.

David Maher / SPORTSFILE

1992

Donegal manager Brian McEniff lifts the Sam Maguire Cup after his team beat Dublin. President Mary Robinson can be seen behind him.

'As a young footballer, your dream is to play for your county in Croke Park on All-Ireland Sunday. This I failed to achieve as a player, so the next best was to manage a team to win an All Ireland for my native county, Donegal.

The journey by bus with a Garda Escort to Croke Park brought great excitement to us all. The sea of green and gold colours as we ran onto the pitch, was followed by, as expected, a nervous opening. The team playing fast, open, direct football, leaving us three points up at half time. Dublin's comeback from 6 points down to 3 points. Declan Bonnar's fourth point, which put us 4 points ahead.

The presentation of the Sam Maguire to our Captain Anthony Molloy and then getting to hold the cup myself, a dream fulfilled. Later to discover what it meant to the Donegal people home and abroad, we had used that as motivation in our preparation for the final. The trip to Malahide, meeting all my own family and friends. Thinking about it still can give me goose pimples, what a great day, what a great time with a great set of boys.

Brian McEniff

1993

'At last!' At the final whistle, Derry Manager Eamonn Coleman celebrates his side's victory over Dublin at Croke Park. Derry went on to beat Cork in the final and secure their first (and so far only) All-Ireland success. All Ireland Football Semi Final, Derry v Dublin.

Ray McManus/SPORTSFILE

Derry had just beaten Dublin to qualify for the All-Ireland Final for only the second time ever. Their manager Éamonn Coleman, who has sadly passed away since, was a real GAA man, who had put years of hard work into seeing his county do well. They had been trailing for the whole match against the much-fancied Dubs, before coming back to snatch the game by a point. The picture shows Éamonn's delight at the final whistle, as he runs onto the pitch to celebrate with his team. The packed old Hogan Stand is the backdrop for a photo which shows the highs of winning a big game in Croke Park. Derry went on to win the All-Ireland that year and this semi-final victory will live long in the memory of their supporters.

Ray McManus, photographer

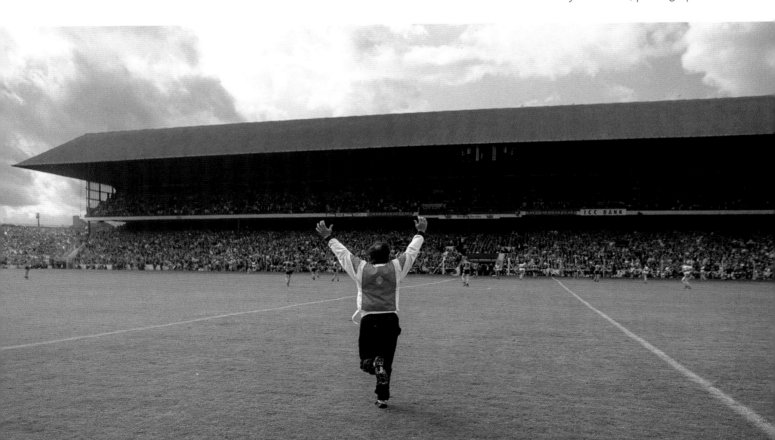

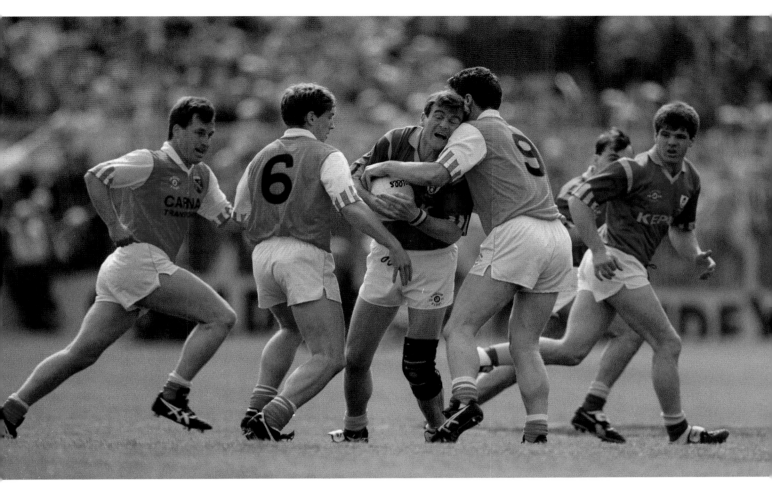

1994

'Thou shall not pass!' Colm O'Rourke, Meath, is tackled by Kieran McGeeney, 6, and Jarlath Burns, 9. Armagh. Armagh v Meath, National Football League Final, Croke Park.

Ray McManus / SPORTSFILE

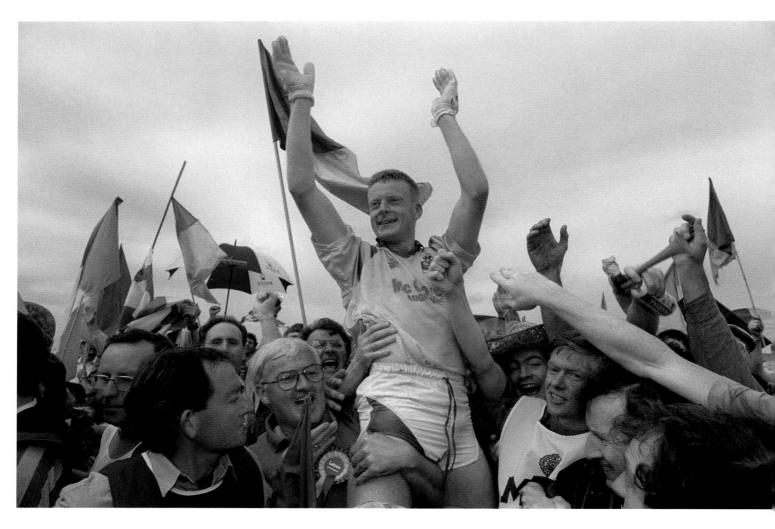

1994

Leitrim captain Declan Darcy celebrates his side's victory, their first in sixty-seven years, in the Connacht Senior Football Championship Final, Mayo v Leitrim, McHale Park, Castlebar, Co. Mayo.

David Maher / SPORTSFILE

1995

Kerry's Séamus Moynihan, Darragh Ó Sé, Maurice Fitzgerald and Liam O'Flaherty go up against Cork's Teddy McCarthy, Liam Honohan and Danny Culloty during the 1995 Munster Senior Football Final. This was famously the last time Cork beat Kerry in Fitzgerald Stadium at championship level.

Brendan Moran / SPORTSFILE

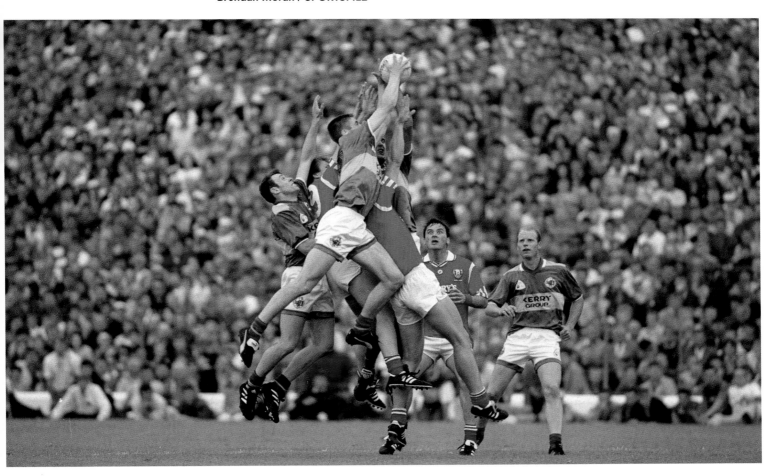

1995

A three-way struggle between Cork's Stephen O'Brien and Larry Tompkins and Kerry's Liam O'Flaherty in the 1995 Munster Football Final in Fitzgerald Stadium, Killarney.

Brendan Moran/SPORTSFILE

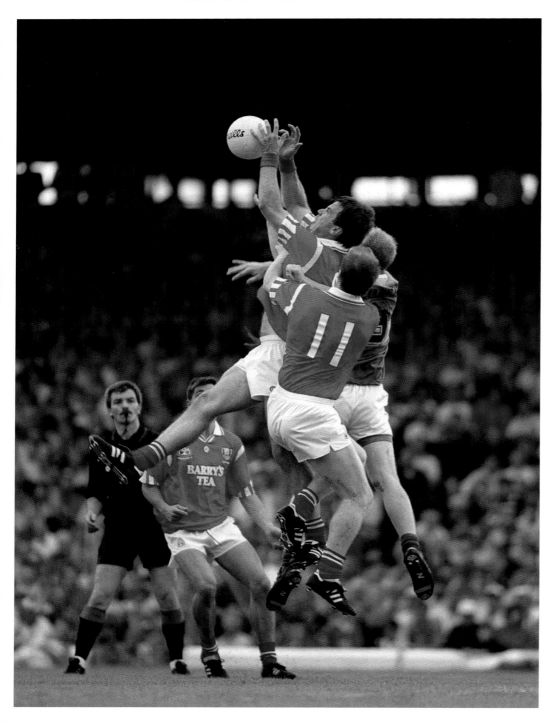

1995

Paul Clarke of Dublin punches the ball into the net for a second-half goal in the 1995 Leinster Football Final on a gloriously sunny day in Croke Park. The Dubs tacked on another five points before the final whistle, beating Meath by a comfortable ten points.

Brendan Moran / SPORTSFILE

1995

Dublin's Jason Sherlock blasts the ball past Cork
goalkeeper Kevin O'Dwyer for what proved to be the
winning goal in the All-Ireland Football Semi-Final, Cork v
Dublin, Croke Park.

David Maher / SPORTSFILE

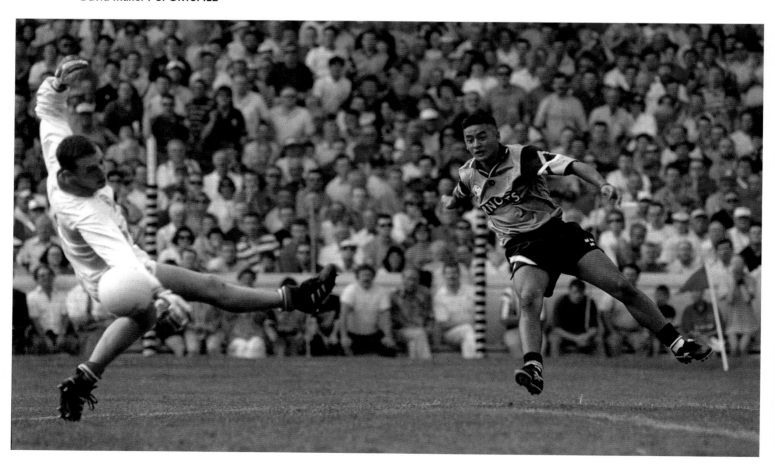

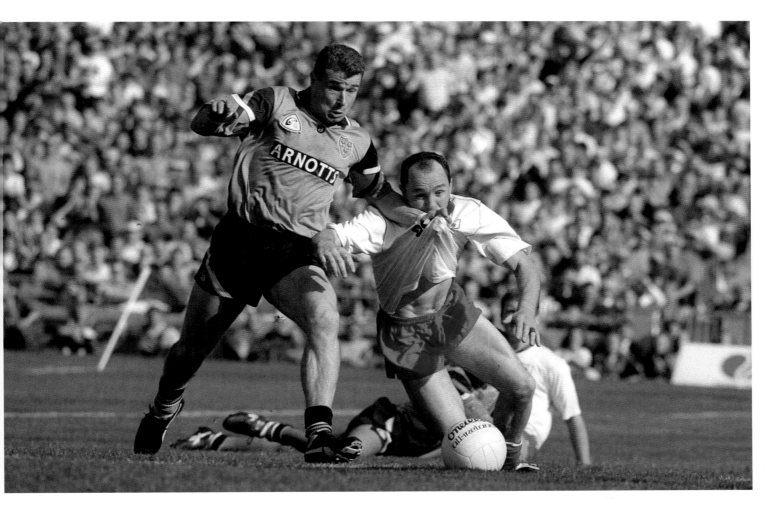

1995

In the 1995 All-Ireland final, Dublin's Charlie Redmond powers forward to score the only goal of the match, despite the efforts of Tyrone's Paul Devlin. Redmond was later sent off but refused to leave the pitch until instructed a second time by referee Paddy Russell.

Brendan Moran / SPORTSFILE

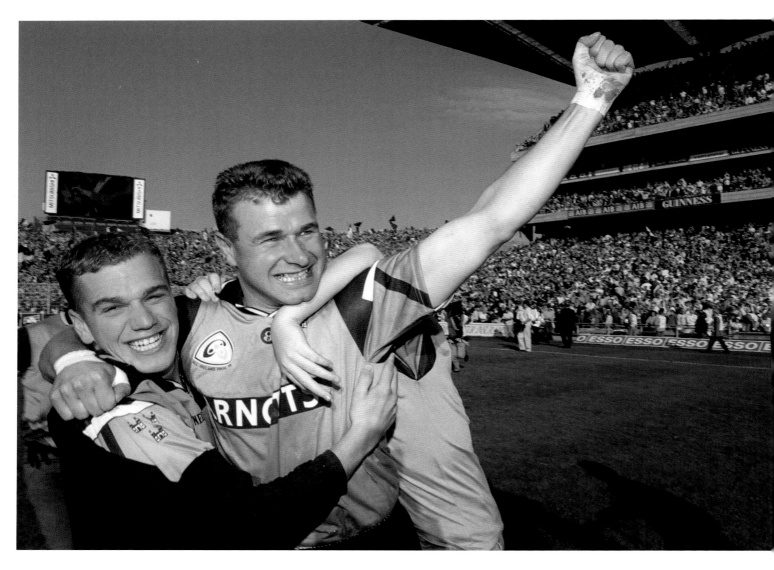

1995

Dublin's Charlie Redmond, sent off earlier in the game, celebrates his team's narrow victory against Tyrone in the 1995 All-Ireland Football Final, Croke Park.

Ray McManus / SPORTSFILE

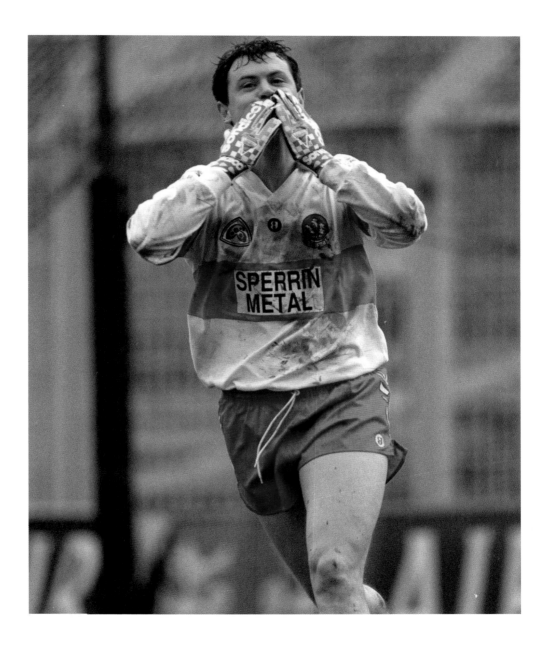

1996

Back in his playing days, Joe Brolly celebrates his goal for Derry against
Mayo in the 1996 National Football League Semi-Final at Croke Park.
Derry would go on to beat Donegal in the final the following month.

Ray McManus / SPORTSFILE

Below: 1996

The view from the newly opened Cusack Stand in Croke Park during the All-Ireland Football Semi-Final between Meath and Tyrone in 1996.

Brendan Moran/SPORTSFILE

Opposite: 1996

Mayo's Liam McHale rises above Meath's John McDermott for the first touch of the All-Ireland Football Final of 1996 in Croke Park. This match ended with a draw; the replay two weeks later is best remembered for the massive brawl that broke out after only six minutes of play.

David Maher / SPORTSFILE

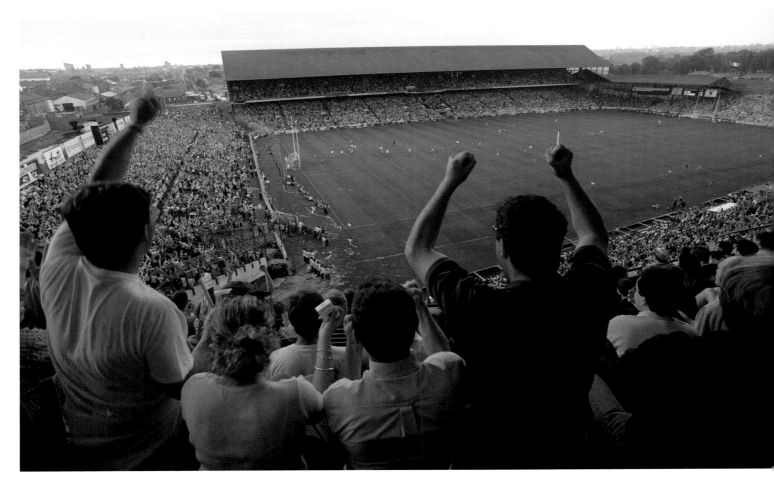

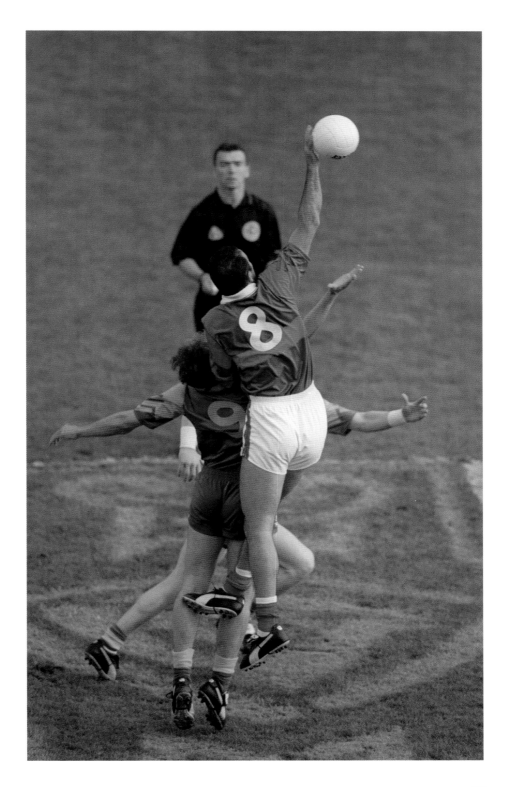

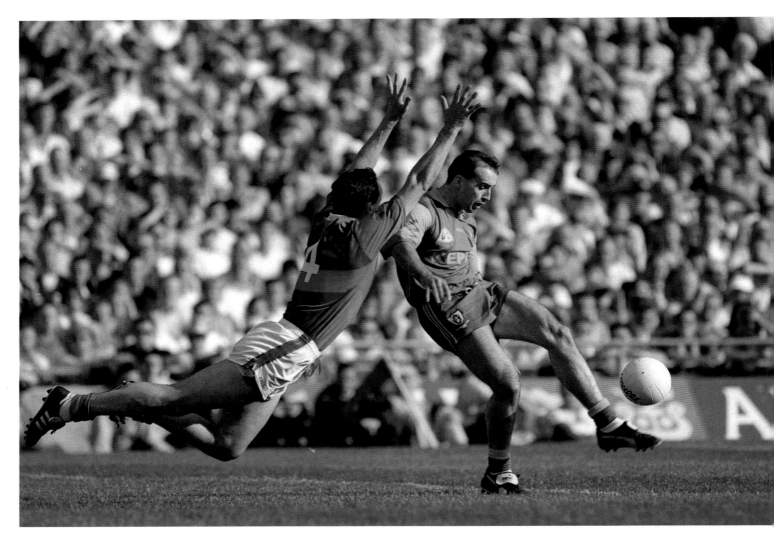

1996

Meath's Jody Devine in action against Dermot Flanagan of Mayo at the All-Ireland Football Final of 1996 in Croke Park.

Brendan Moran / SPORTSFILE

1996

The infamous altercation between Meath and Mayo players early in the All-Ireland Football Final Replay of 1996, which resulted in Meath's Colm Coyle and Mayo's Liam McHale being sent off by referee Pat McEnaney. Croke Park.

David Maher / SPORTSFILE

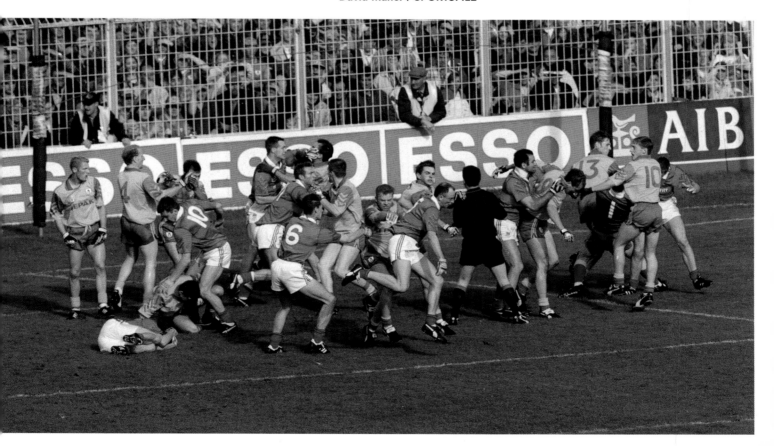

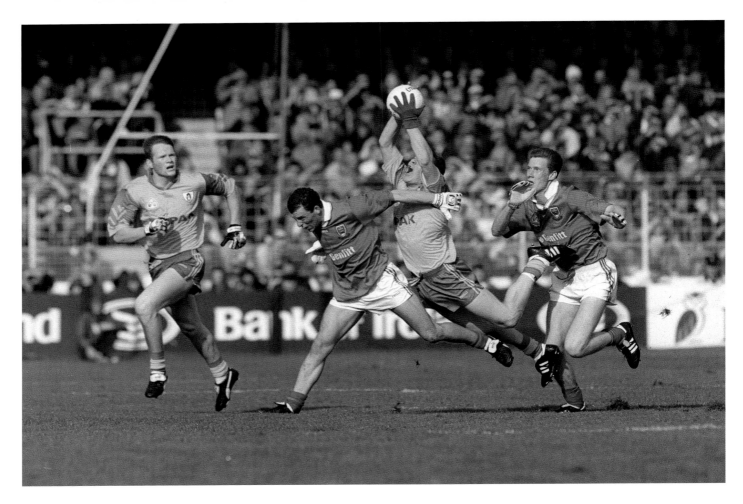

1996

From left, Jimmy McGuinness (Meath), Kenneth
Mortimer (Mayo), Tommy Dowd (Meath, with the ball)
and James Nallen (Mayo) in action at the All-Ireland
Football Final Replay in Croke Park. Dublin.

Brendan Moran / SPORTSFILE

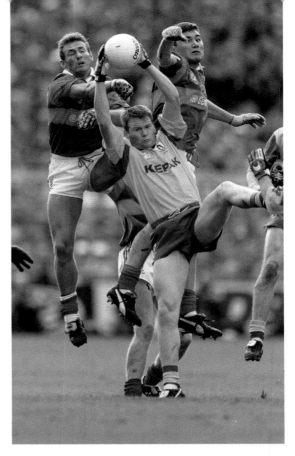

Right: 1996

Meath's Jimmy McGuinness gets the better of Mayo's Colm McManamon and James Horan. All-Ireland Football Final Replay 1996, Croke Park.

Ray Mc Manus/SPORTSFILE

Below: 1996

Meath captain Tommy Dowd scores the goal that gave his team the lead in the second half of the All-Ireland Football Final Replay 1996 in Croke Park. Meath would go on to win by a single point.

Ray McManus / SPORTSFILE

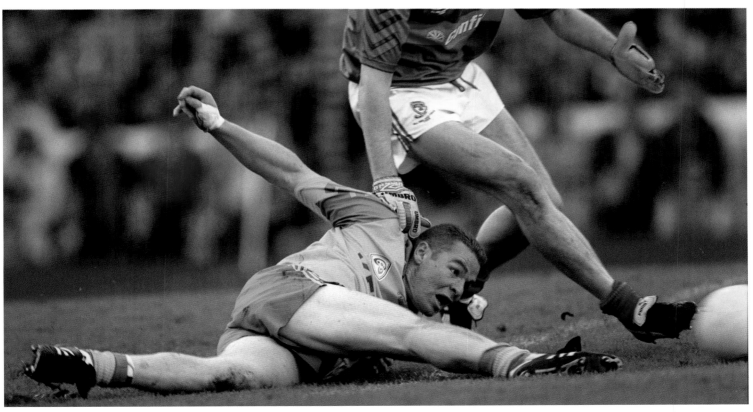

1997

Maurice Fitzgerald adjusts his collar during the parade prior to the All-Ireland Football Final 1997 in Croke Park. Kerry would end their eleven-year barren spell with a three-point victory over Mayo.

Brendan Moran / SPORTSFILE

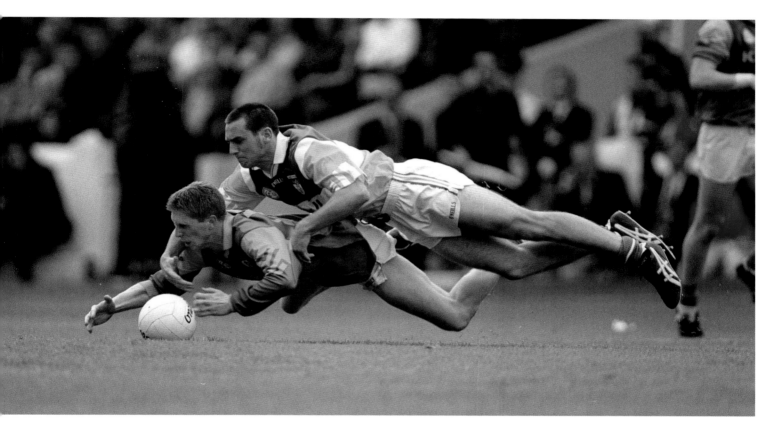

1998

Offaly's Barry Malone in a tussle for possession with Meath's Raymond Magee in the 1998 Leinster Senior Football Quarter-Final in Croke Park. Meath turned in a clinical performance against the reigning Leinster champions, winning out by 3-10 to 0-7.

Ray McManus / SPORTSFILE

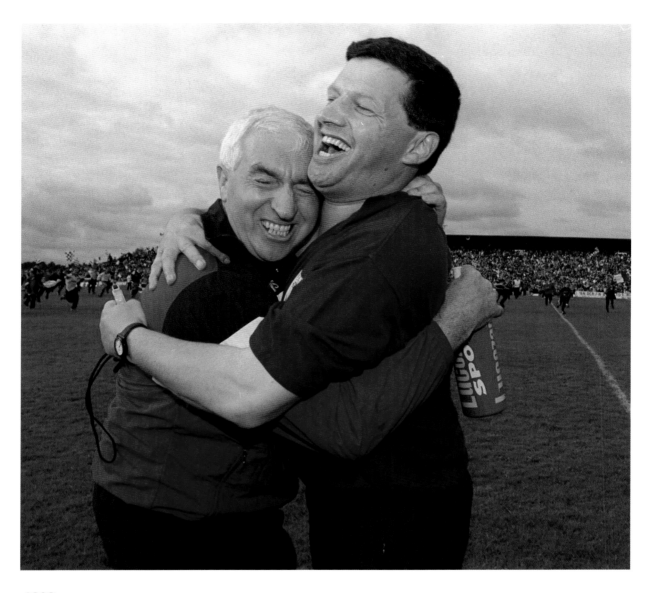

1998

Galway manager, John O'Mahony, and assistant physio, Mick Byrne, left, andcelebrate their victory over Roscommon in the Connacht Football Final Replay 1998 in Dr Hyde Park, Roscommon.

Brendan Moran / SPORTSFILE

1998

A young Kildare fan cheers on his side, who would beat Meath by five points in a thrilling Leinster Senior Football Championship Final in Croke Park, Dublin, in 1998.

Ray McManus / SPORTSFILE

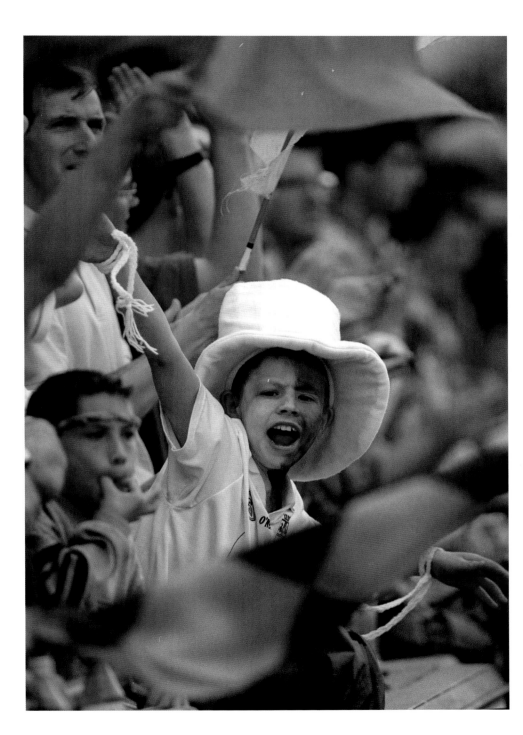

1998

Galway's Michael Donnellan in action against Kildare's Brian Lacey in the 1998 All-Ireland Football Final in Croke Park. Kildare had seen off the 1995, 1996 and 1997 champions (Dublin, Meath and Kerry) in earlier rounds, but could not keep pace with Galway on the day. The Tribesmen won the All-Ireland title for the first time in thirty-two years.

Brendan Moran/SPORTSFILE

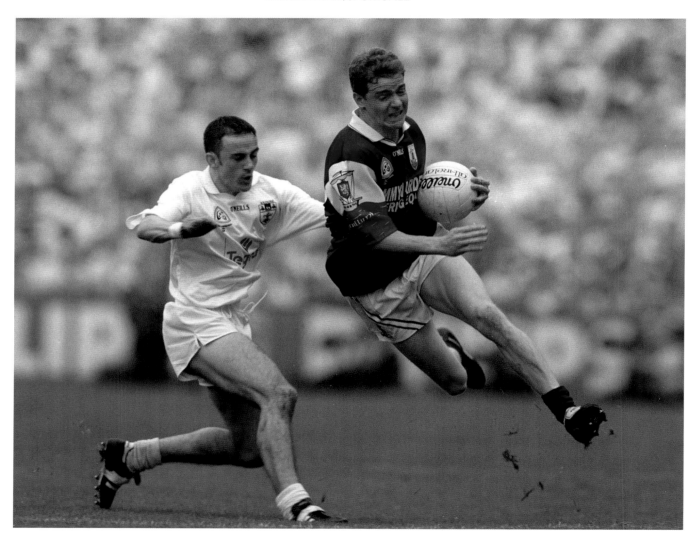

1999

Westmeath's Fergal Wilson celebrates victory over Kerry at the final whistle in the 1999 All-Ireland U-21 Football Final at the Gaelic Grounds in Limerick, the county's first and only U-21 championship win.

Ray McManus / SPORTSFILE

1999

Tom Ryan of Roscommon in action against Jason Ward (left) and Brendan Guckian of Leitrim in the 1999 Connacht Football Championship Quarter-Final at Páirc Seán Mac Diarmada, Carrick-on-Shannon, Co. Leitrim.

Brendan Moran / SPORTSFILE

1999

Offaly manager Tommy Lyons celebrates with a fan
their team's victory over Kildare in the Leinster Football
Championship Quarter-Final of 1999 in Croke Park. They
would be beaten in the semis by the eventual All-Ireland
champions, Meath.

Damien Eagers / SPORTSFILE

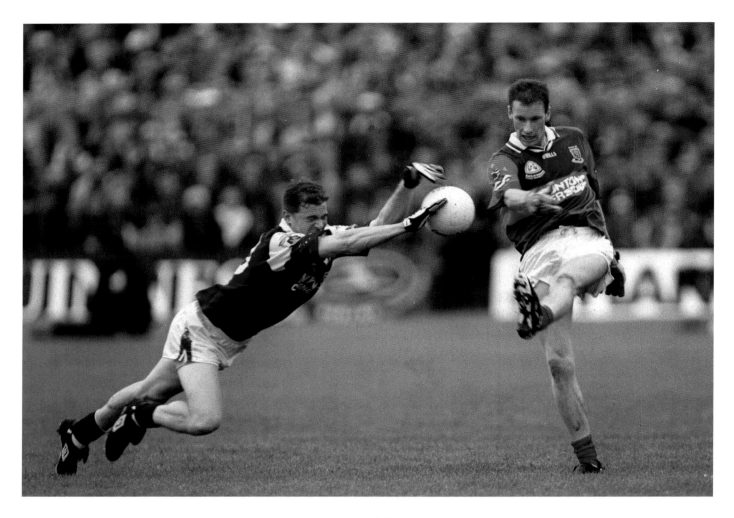

1999

James Nallen of Mayo has his shot blocked by Michael Donnellan of Galway – but Mayo would record a sweet victory by beating their old rivals, who were reigning All-Ireland Champions, in their home pitch of Tuam in this Connacht Final of 1999.

Matt Browne / SPORTSFILE

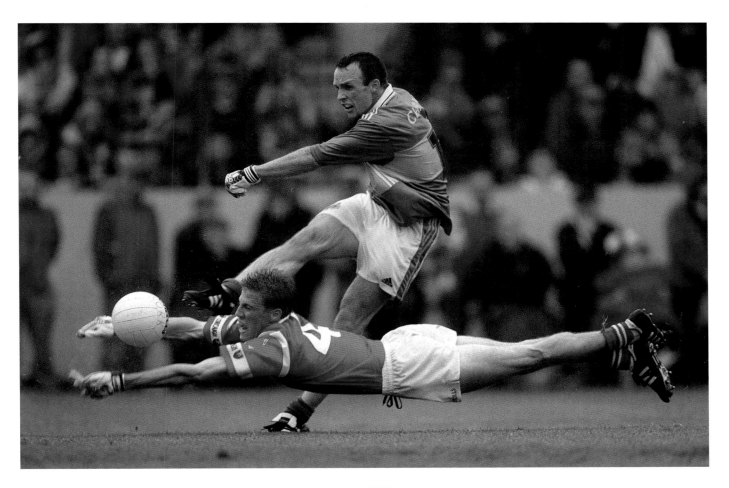

1999

Cork's Anthony Lynch attempts to block down
a shot by Kerry's John Crowley in the Munster
Football Final 1999 at Páirc Uí Chaoimh. Cork
won out 2-10 to 2-04 over the reigning Munster
champions and made it to the All-Ireland final,
where they were beaten by Meath.

Brendan Moran / SPORTSFILE

This photo was taken after the Leinster final in 1999. I have no recollection of the day whatsoever, but my parents tell me that our family got tickets about two to three rows from the front of the Cusack stand, adjoining Hill 16. The Delaney Cup was presented in the middle of the pitch and no supporters were allowed out on the pitch. We waited for Graham Geraghty to come down to our section afterwards and we went down to the barrier. The photographers suggested putting the child into the cup and Graham lifted the cup and myself overhead. I clearly wasn't too happy with the situation and was staring at my dad, wearing the black watch in the picture. A friend rang early the next morning to tell us that the photo was on the front page of the *Irish Times*, John Creedon had picked it as his picture of the day on his early morning show! It also appeared in some of the other daily papers. Subsequently it was on the cover of *A Season of Sundays* (which still sits in our living room) and it was also used on the O'Neills website. Those were the days when Meath were ranked among the top teams in Ireland and indeed Meath went on to win the All Ireland that year.

Cormac Maguire

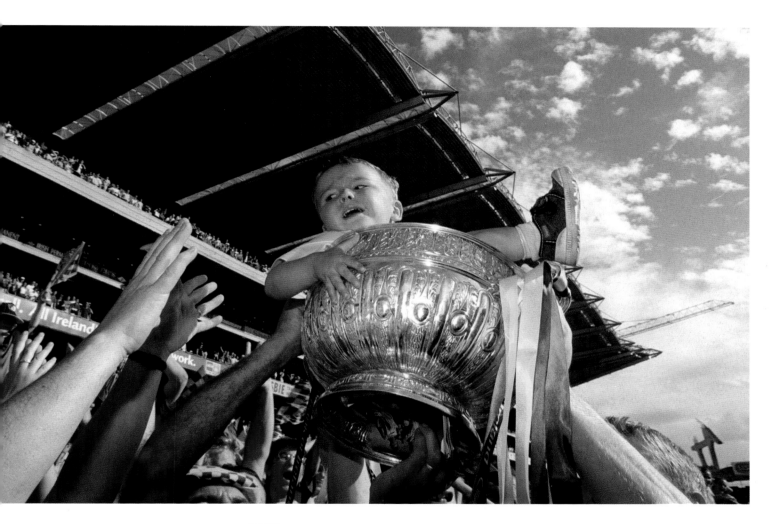

1999

Two-year-old Cormac Maguire from Slane is lifted in the Leinster Football Championship trophy by Meath captain Graham Geraghty. Meath v Dublin, 1999 Leinster Football Final, Croke Park.

Brendan Moran / SPORTSFILE

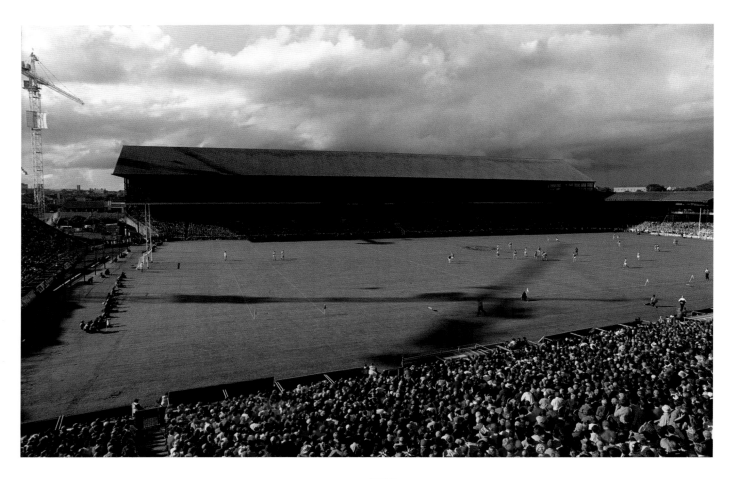

1999

Croke Park pictured at the start of the All-Ireland Senior Football Final 1999 between Meath and Cork. The last final of the century was also the last final of the old Hogan Stand, which was demolished later that year.

Brendan Moran / SPORTSFILE

1999

Meath manager Seán Boylan lifts the cup after a tense All-Ireland Football Final against Cork in Croke Park in 1999. After many twists and turns– including an exceptional goal by Cork centre-forward Joe Kavanagh in the second half – the Royals clinched victory by 1-11 to 1-8.

Ray McManus/SPORTSFILE

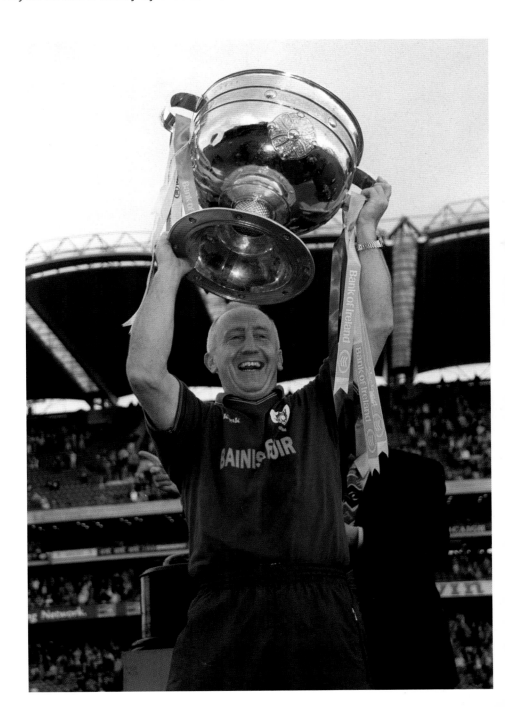

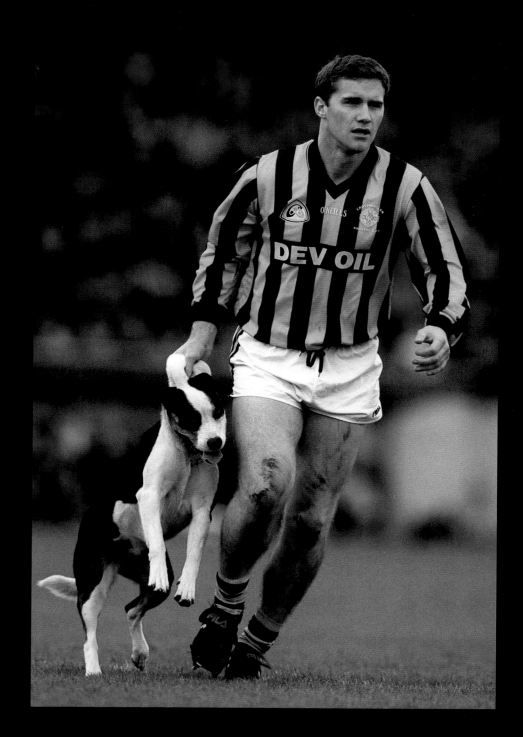

2000

Crossmaglen Rangers forward Tony McEntee carries a stray dog off the pitch during the 2000 All-Ireland Club Football Semi-Final between Crossmaglen and UCC in Parnell Park, Dublin.

Brendan Moran / SPORTSFILE

2000s

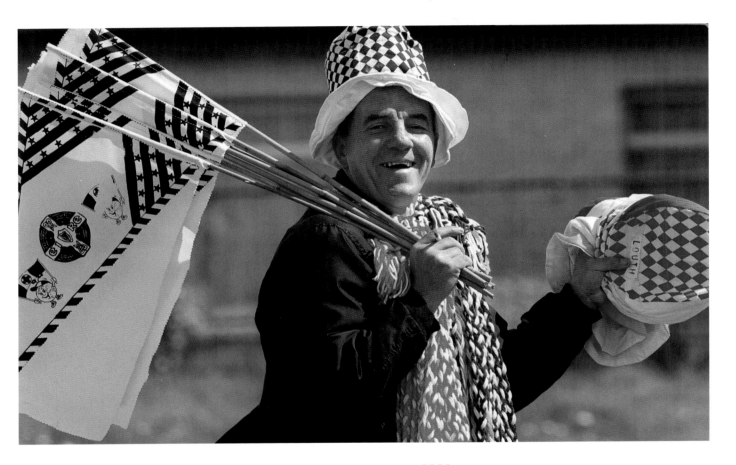

2000

A flag-seller plies his trade prior to the 2000 National Football League Semi-Finals in Cusack Park, Mullingar.

Ray McManus / SPORTSFILE

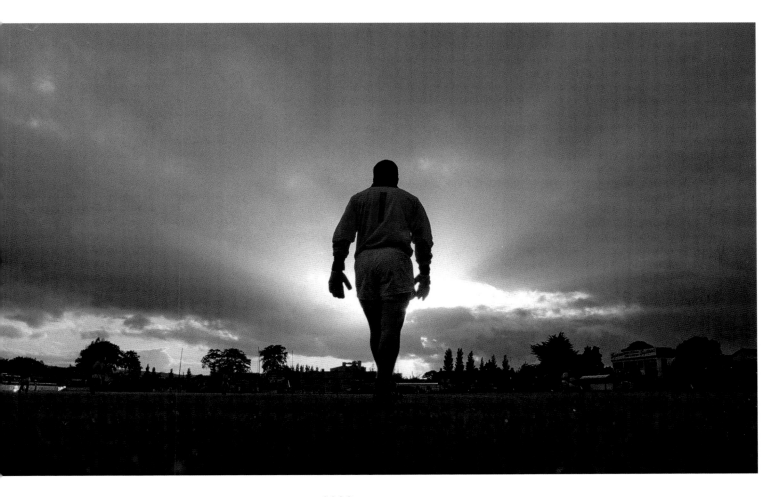

2000

The sun sets on Carlow goalkeeper John Brennan during a Saturday-evening game against Longford in Dr Cullen Park, Carlow, at the early stages of the 2000 Leinster Football Championship.

Ray McManus / SPORTSFILE

2000

Referee Brian White, second from left, and his match officials shelter from the rain before the 2000 Connacht Senior Football Championship Semi-Final between Sligo and Galway in Markievicz Park, Sligo.

Brendan Moran/SPORTSFILE

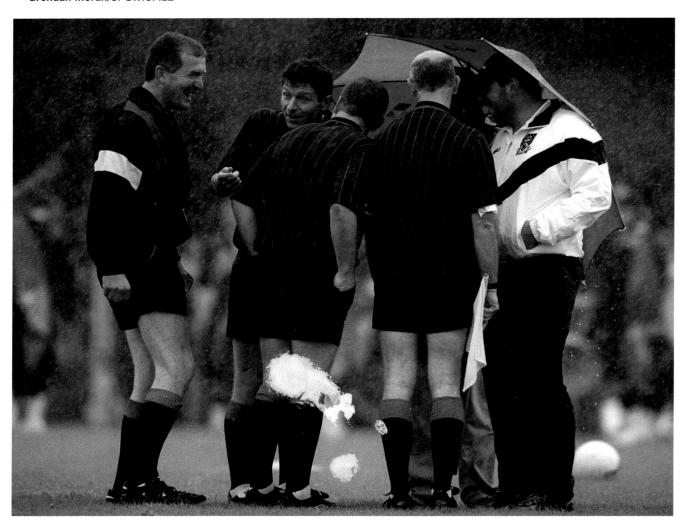

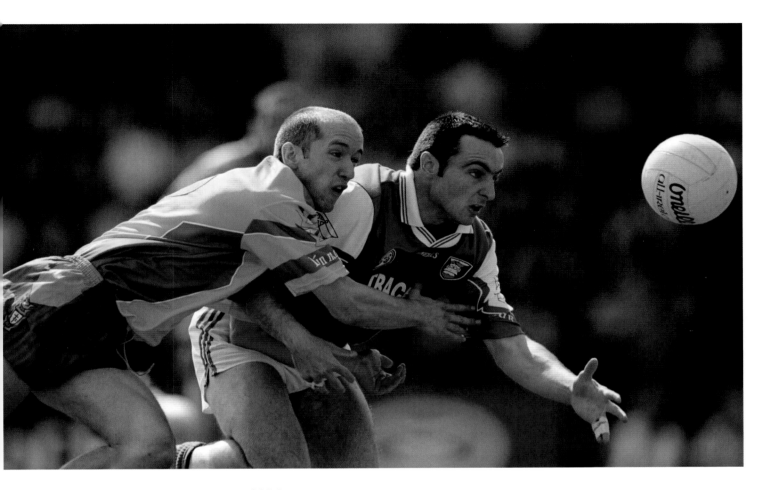

2001

Stephen Maguire, Fermanagh in action against Eamon Doherty, Donegal,
Ulster Football Championship, Donegal v Fermanagh, Ballybofey,
Co. Donegal. The match ended in a draw; in the replay on 19 May,
Fermanagh were victorious, 1-09 to 0-11.

Damien Eagers / SPORTSFILE

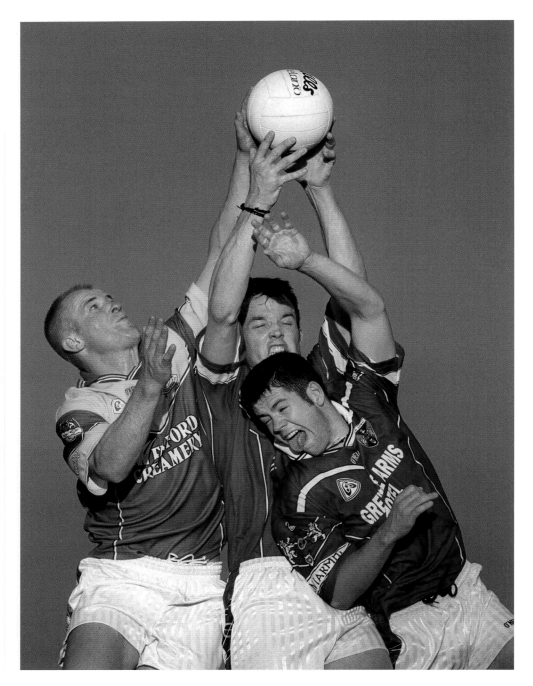

2001

Westmeath's Rory O'Connell, centre, fields a high ball ahead of team-mate Brian Morley and Wexford's Willie Carley. All-Ireland Football Championship Qualifier, Round 1, Wexford Park, Wexford. This was the first year the qualifier system – where teams knocked out of the provincial competitions entered another competition to get a second crack at qualifying for the All-Ireland series – was used.

Brendan Moran / SPORTSFILE

2001

Roscommon manager, John Tobin, in his team's dressing room at the end of the game after Roscommon's victory – their first Connacht title in ten years – over Mayo. All-Ireland Senior Football Championship Final, Dr Hyde Park, Co. Roscommon.

David Maher / SPORSTFILE

2001

The calm before the storm: the dressing rooms at Croke Park. All-Ireland Senior Football Championship Qualifier, Round 3, Kildare v Sligo, Croke Park. This was the first time that Sligo played in a predominantly black jersey, due to a colour clash with Kildare; Sligo won and have worn black ever since.

Ray McManus / SPORTSFILE

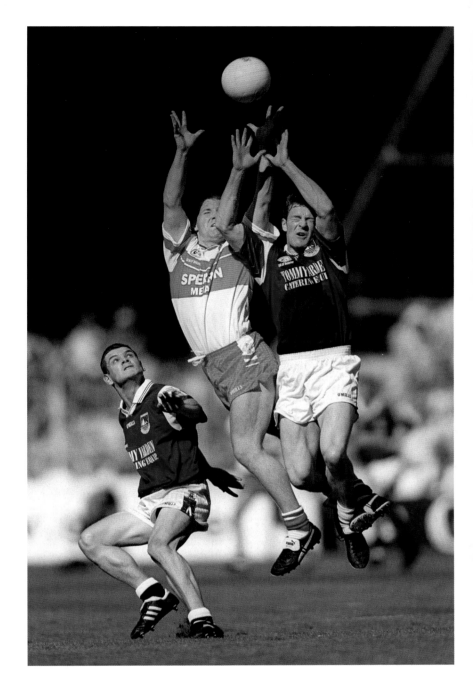

2001

Jarlath Fallon, Galway, contests a dropping ball with Johnny McBride, Derry, watched by Galway's Declan Meehan. Galway won the match 1-14 to 1-11. All-Ireland Senior Football Championship Semi-Final, Croke Park.

Ray McManus / SPORTSFILE

2001

Meath's Ollie Murphy gets over the tackle of Kerry's Eamon Fitzmaurice.
Meath v Kerry, All Ireland Senior Football Semi-Final, Croke Park. In an
amazing game for Meath they beat a star-studded Kerry team 2-14 to 0-5;
no Kerry player scored more than a single point.

Brendan Moran / SPORTSFILE

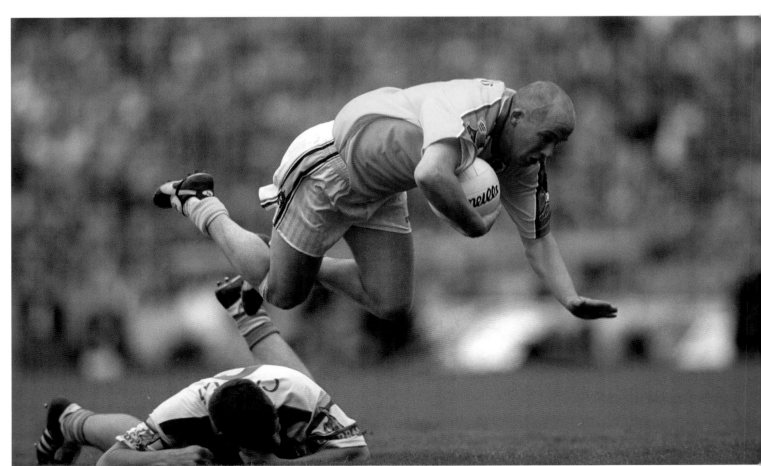

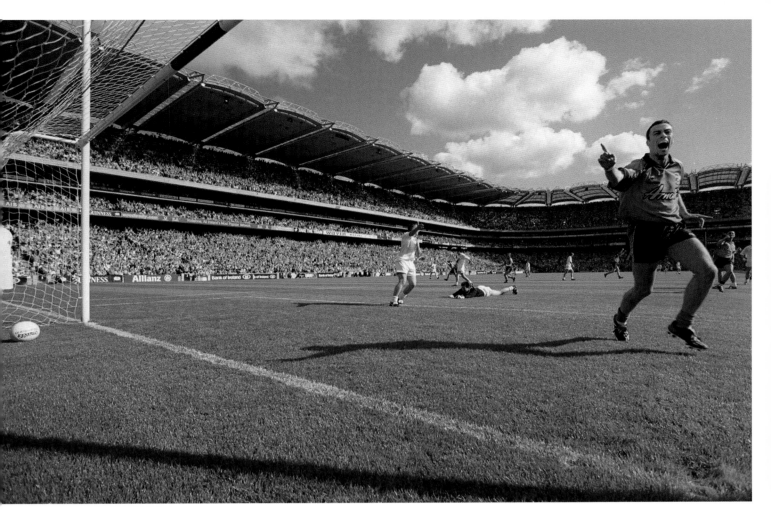

2002

Dublin's 'Hero of the Hill' Ray Cosgrove celebrates his side's first goal;
Dublin went on to beat Kildare 2-13 to 2-11, to secure their first Leinster title
in seven years. Leinster Senior Football Championship Final, Croke Park.

Damien Eagers / SPORTSFILE

2002

Dejected Tipperary players Declan Browne, left, and Philly Ryan after
losing 0-07 to Cork's 1-23. Munster Football Final Replay, Cork v
Tipperary, Páirc Uí Chaoimh, Cork.

Brendan Moran / SPORTSFILE

2002

Sligo's Tommy Brennan in action against Paul McCormack, Armagh. Armagh v

Sligo, All Ireland Football Quarter-Final, Croke Park.

Matt Browne / SPORTSFILE

2002

Croke Park, 3.29pm, a minute before the start of the game. Kerry v Armagh, All Ireland Senior Football Final, Croke Park.

Brendan Moran / SPORTSFILE

2002

Kerry's Darragh Ó Sé fields a high ball in front of
goal. Kerry v Armagh, All Ireland Football Final,
Croke Park.

Damien Eagers / SPORTSFILE

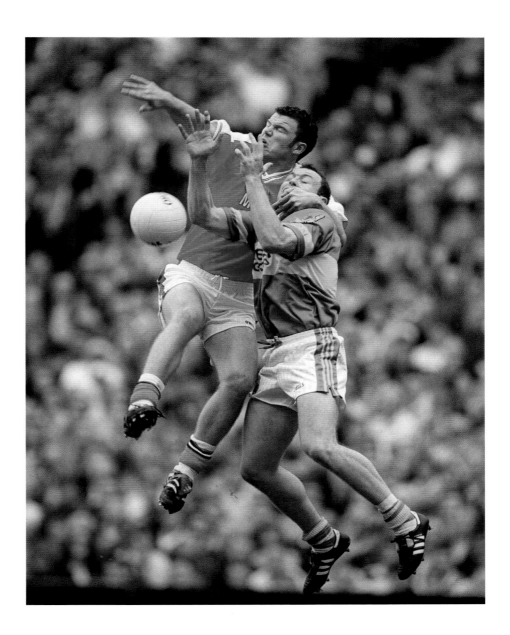

2002

Ronan Clarke, Armagh, in action against Kerry's Seamus Moynihan in the All Ireland Senior Football Final, Croke Park. Scores from Ronan and Steven McDonnell (who also scored the first point of the day) put Armagh in the lead and, along with a goal from Oisín McConville, propelled the Orchard County their first Championship win.

David Maher / SPORTSFILE

2002

Armagh manager Joe Kernan celebrates after victory over Kerry in the All Ireland Football Final, Croke Park.

Brendan Moran / SPORTSFILE

People say on big days that matches pass you by; I remember every minute. When Steven McDonnell scored the winner from a great diagonal pass from Aidan O'Rourke, the last eleven minutes seemed like slow motion. No more scores. I thought the final whistle would never blow. When the final whistle did go my first reaction was just relief. Thank God it's over! Then suddenly you realise that everyone's dream has come true – the players, the backroom team, your families and the supporters who thought this day would never come. Goose pimples just thinking of the moment!

Joe Kernan

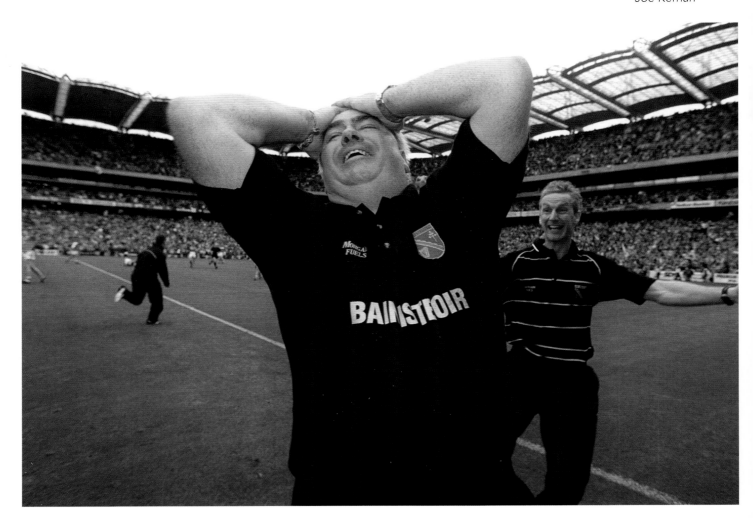

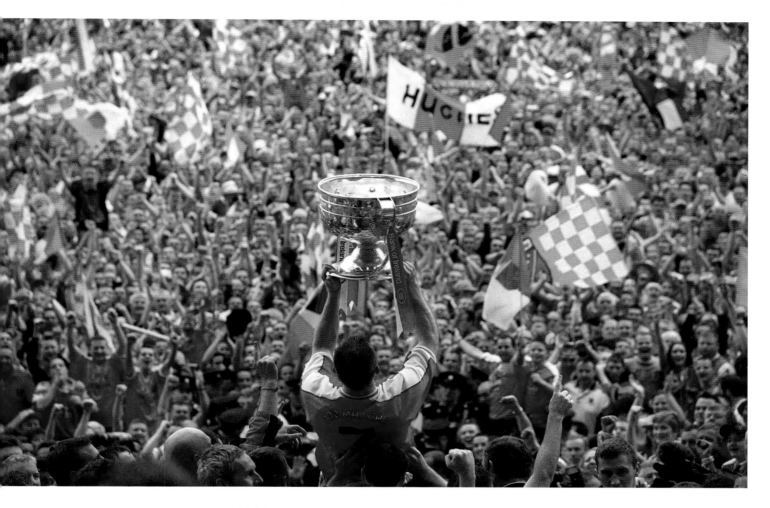

2002

Armagh's Justin McNulty lifts the Sam Maguire in front of his team's fans.

Kerry v Armagh, All Ireland Football Final, Croke Park.

Brendan Moran / SPORTSFILE

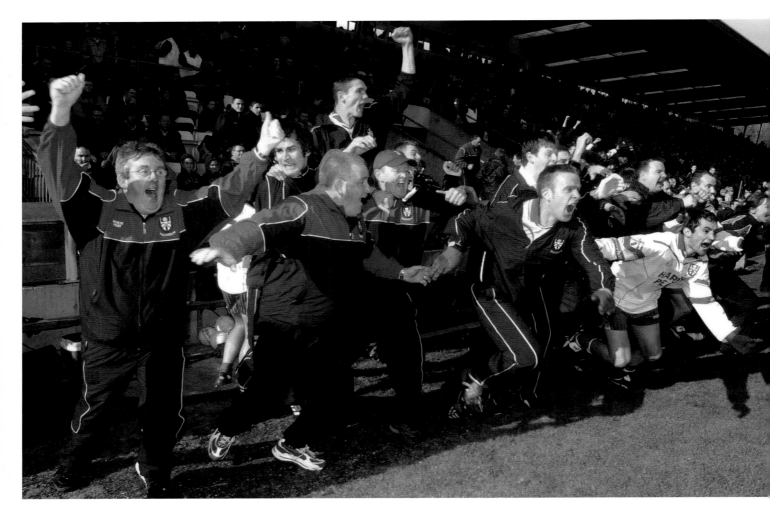

2003

Monaghan players and officials celebrate at the end of the game after victory over reigning All-Ireland champions, Armagh. Ulster Senior Football Championship, St Tiernach's Park, Clones, Co. Monaghan.

David Maher / SPORTSFILE

2003

Dara Ó Cinnéide, Kerry, is surrounded by Tyrone players, left to right, Kevin Hughes, Philip Jordan, and Gavin Devlin. Tyrone's intensity in their tackling led former Kerry star and Sunday Game analyst Pat Spillane to use the term 'puke football', to describe the Tyrone tactics that day. The Red Hand County men won the game, 0-13 to 0-6, before going on to win their first All-Ireland title against neighbours Armagh. All-Ireland Senior Football Championship Semi-Final, Croke Park,.

David Maher / SPORTSFILE

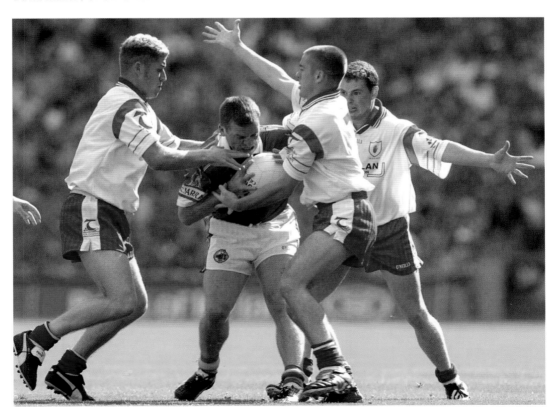

2003

Tyrone's Conor Gormley blocks a late shot from Armagh's Steven McDonnell; McDonnell later described it as 'one of the best tackles ever'. All-Ireland Senior Football Championship Final.

Brendan Moran / SPORTSFILE

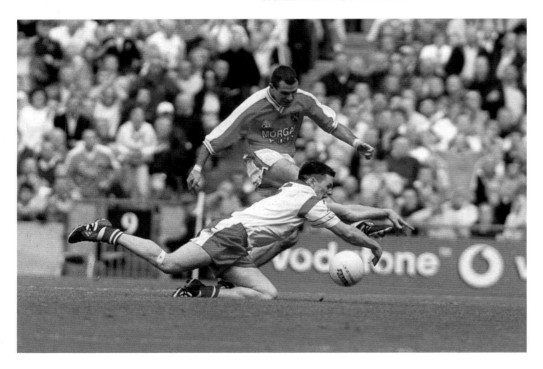

2003

Tyrone fans celebrate on the pitch for a full hour after victory over Armagh.

All-Ireland Senior Football Championship Final, Croke Park.

Ray McManus / SPORTSFILE

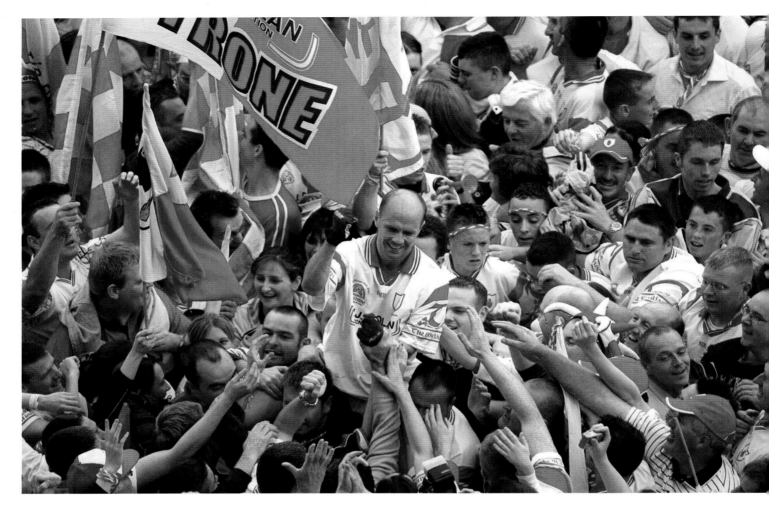

2003

Tyrone captain Peter Canavan is held aloft by the crowd after victory over Armagh. All-Ireland Senior Football Championship Final, Croke Park.

Ray McManus / SPORTSFILE

2004

Roscommon goalkeeper Shane Curran fails to stop a penalty from Sligo's Paul Taylor. Connacht Senior Football Championship Replay, Markievicz Park, Sligo.

Damien Eagers / SPORTSFILE

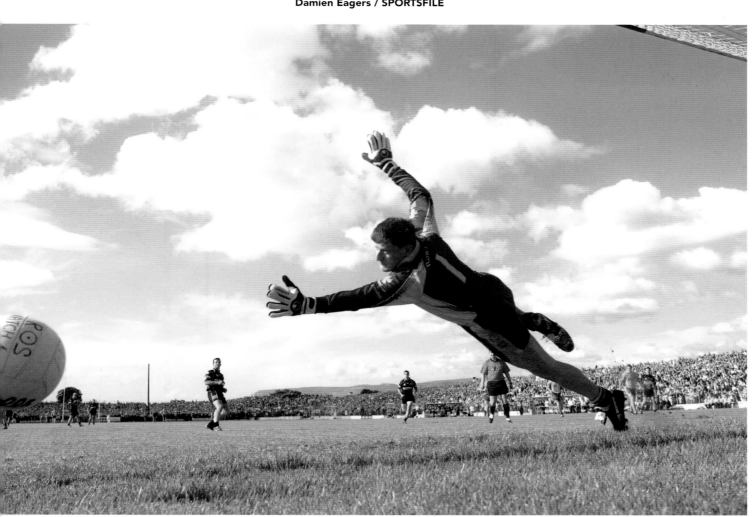

2004

Fermanagh priest Fr Brian D'Arcy celebrates with Fermanagh player Liam McBarron after victory over Cork. Senior Football Championship Qualifier, Round 3, Croke Park.

Ray McManus / SPORTSFILE

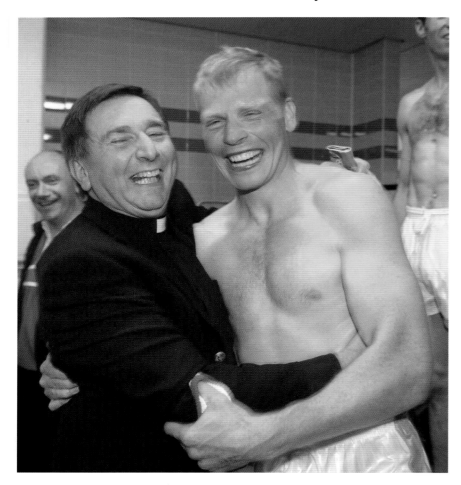

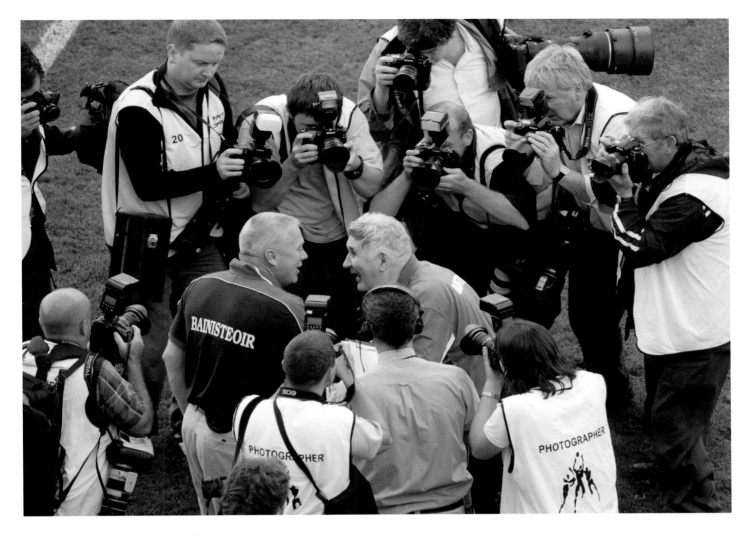

2004

'Until the next time …' Laois manager Mick O'Dwyer and Westmeath manager Páidí Ó Sé shake hands as shutters click all round them at the end of the game. Leinster Senior Football Championship Final, Croke Park.

Ray McManus / SPORTSFILE

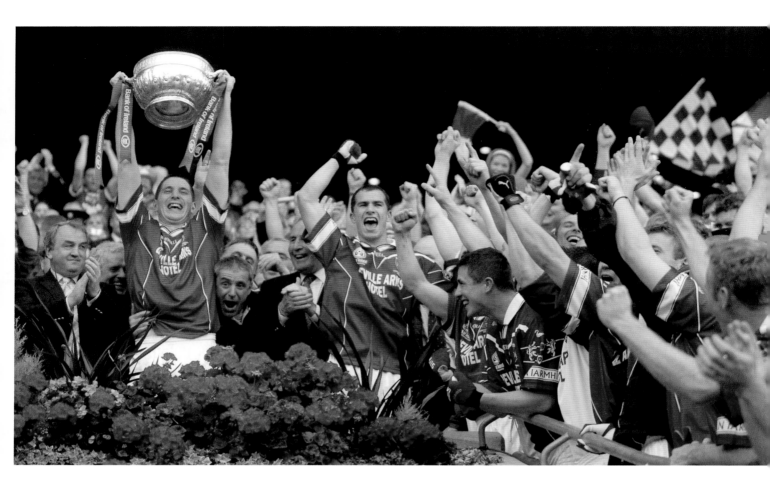

2004

Westmeath captain David O'Shaughnessy lifts the Leinster cup after victory over Laois; this was the first ever Leinster title for Westmeath. Leinster Senior Football Championship Final Replay, Croke Park.

Brendan Moran / SPORTSFILE

2005

Kildare captain, John Doyle, leaps for the ball against Westmeath's Damien Healy; Doyle scored six of his team's points in a bruising match against the Lake County. Leinster Senior Football Championship, Croke Park.

Damien Eagers / SPORTSFILE

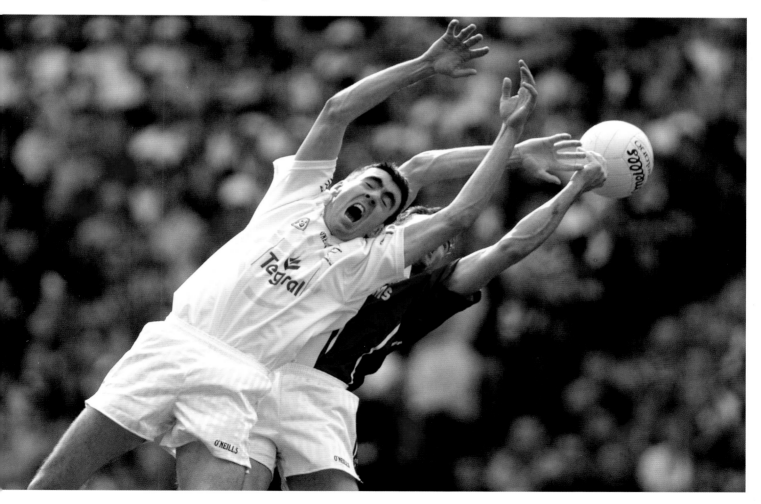

2005

Mayo's Conor Mortimer leaves the field after defeat by Kerry.

Senior Football Championship Quarter-Final, Croke Park.

Brendan Moran / SPORTSFILE

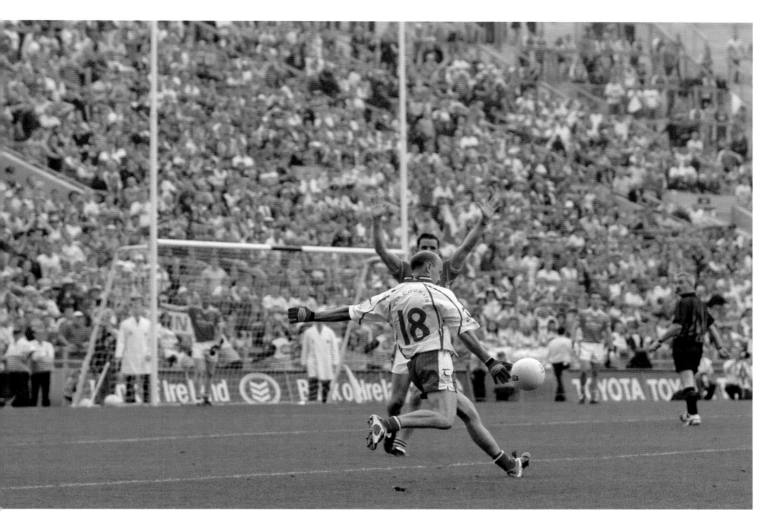

2005

Peter Canavan, Tyrone, kicks the winning point for victory over Armagh in injury time as Paul McGrane, Armagh, attempts to block. All-Ireland Senior Football Championship Semi-Final, Croke Park.

David Maher / SPORTSFILE

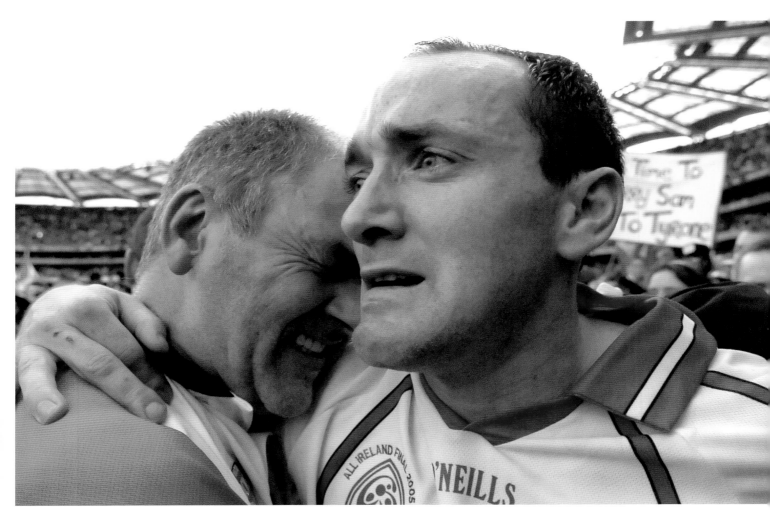

2005

Tyrone captain Brian Dooher, right, celebrates with a tearful Tyrone manager Mickey Harte after their team beat Kerry 1-16 to 2-10. Tyrone had to play ten games (including three replays) in order to win the Championship – more than any other team before or since. All-Ireland Senior Football Championship Final, Croke Park.

Brendan Moran / SPORTSFILE

2006

Alan Dillon, Mayo, in action against London goalkeeper Brian McBrearty, Connacht Senior Football Championship, Preliminary Round, Emerald Gaelic Grounds, Ruislip, London, England.

Damien Eagers / SPORTSFILE

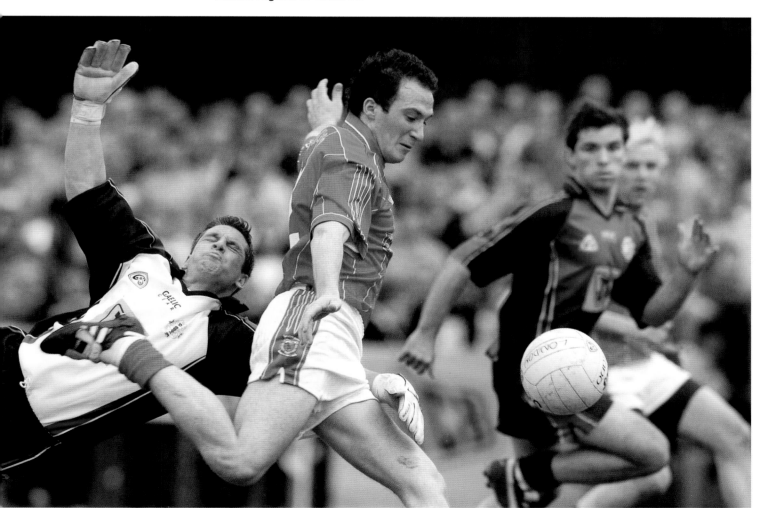

2006

Kieran Donaghy, Kerry, shoots past the Armagh goalkeeper, Paul Hearty, to score his side's second goal, All-Ireland Senior Football Championship Quarter-Final, Croke Park. Donaghy started the year as a midfielder, but was switched into full forward during the qualifiers. The move would see him cause havoc at the edge of the square and finish up as All-Star Footballer of the Year.

Ray McManus / SPORTSFILE

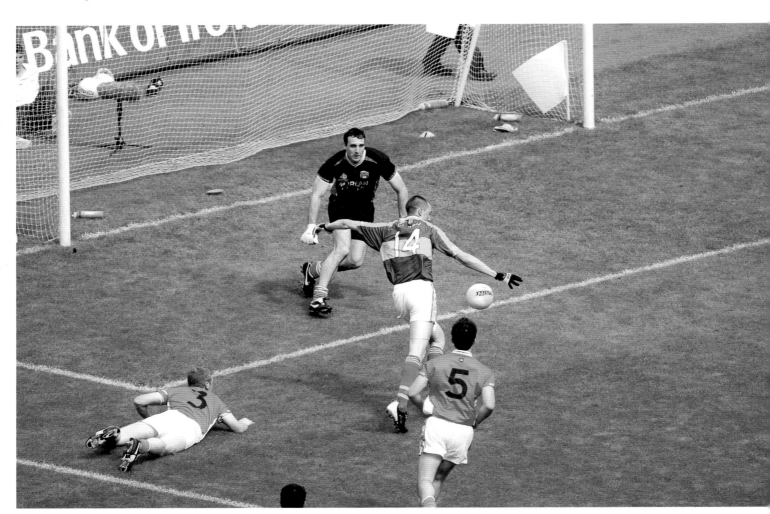

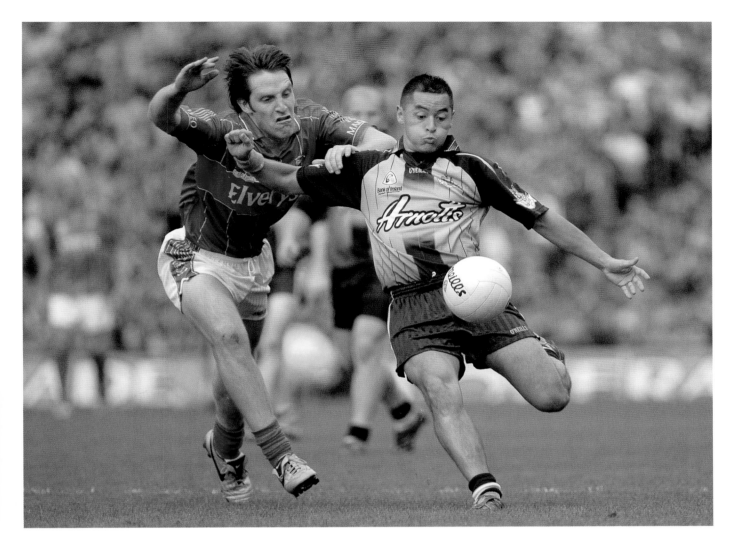

2006

Mayo's Billy Joe Padden moves in on Dublin's Jason Sherlock. Mayo came back from being seven points down in this game to secure victory with a late Ciarán McDonald point, which booked their place in the All-Ireland Final. All-Ireland Senior Football Championship Semi-Final, Croke Park.

Brian Lawless / SPORTSFILE

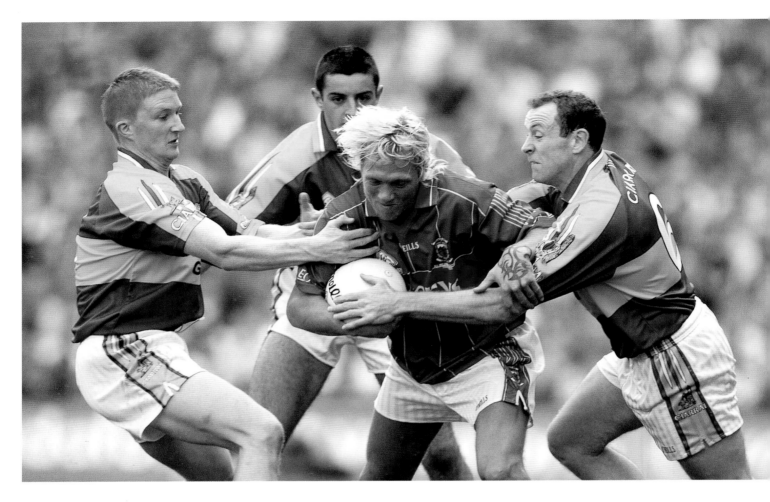

2006

Ciaran McDonald, Mayo, is tackled by Mike Frank Russell, left,
Aidan O'Mahony and Seamus Moynihan, Kerry. All-Ireland Senior
Football Championship Final, Croke Park. In a repeat of the 2004
final, Kerry beat Mayo 4-15 to 3-05.

Brendan Moran / SPORTSFILE

2006

Donal Shine, Roscommon, celebrates after the final whistle, as his county win their first All-Ireland at this grade in fifty-five years. All-Ireland Minor Football Championship Final Replay, Kerry v Roscommon, Cusack Park, Ennis, Co. Clare.

Ray Ryan / SPORTSFILE

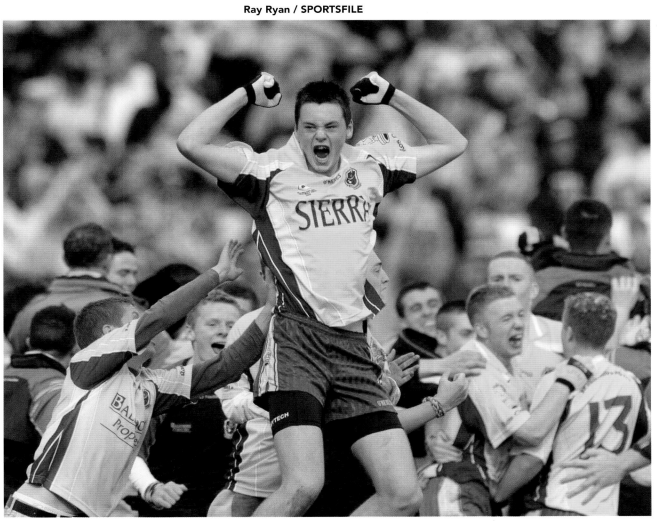

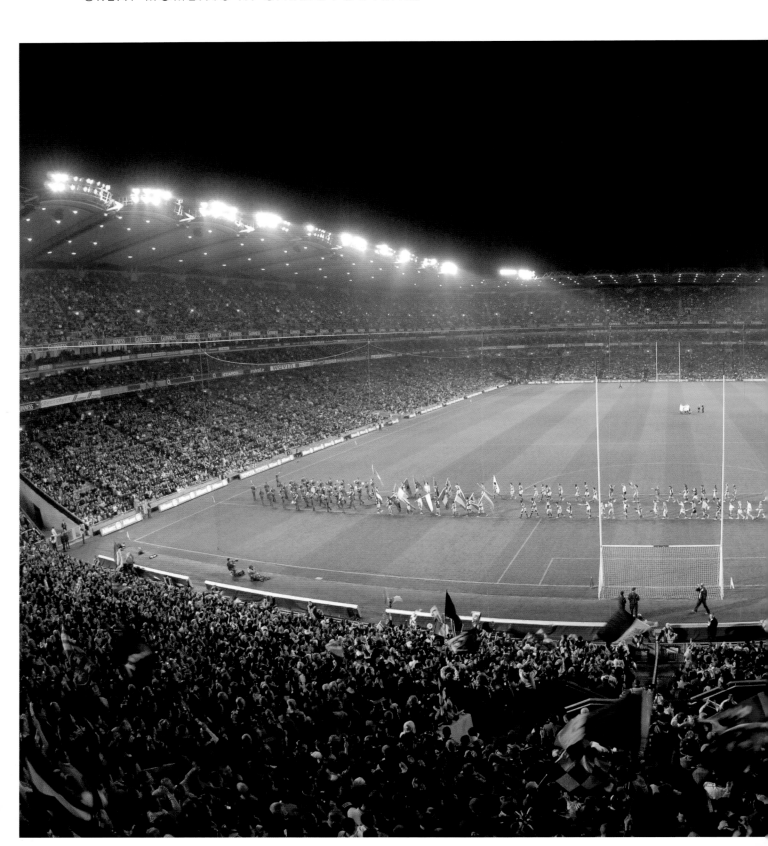

2007

The Artane Band leads the Dublin and Tyrone teams during the parade before the start of the game. Allianz NFL Division 1A, Croke Park.

David Maher / SPORTSFILE

This was the first floodlit game in Croke Park in the history of the GAA, and also the highest attended game in the world that weekend with over 81,000 people in attendance. What I like about this picture: the Artane band, children and players are all perfectly placed. What made this possible was the direction the parade took around the pitch as opposed to the normal direction All Ireland finalists take. Also, I like having almost the complete width of the pitch in Croke Park in the photo. It is always nice to capture an image which is part of photographic sporting history even though neither of these teams reached the All Ireland final in September.

David Maher, photographer

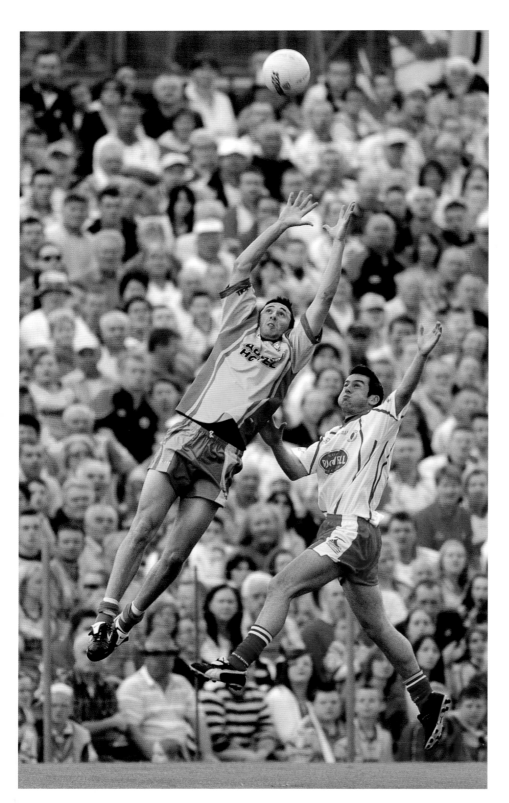

2007

Airborne! Rory Kavanagh, Donegal, leaps high against Sean Cavanagh, Tyrone. Ulster Senior Football Championship Semi-Final, St Tiernach's Park, Clones, Co Monaghan.

Paul Mohan / SPORTSFILE

2007

Owen Mulligan, Tyrone, powers past Dessie Mone, Monaghan. Ulster Senior
Football Championship Final. After being played in Croke Park for the previous three
years, the Ulster final returns to St Tiernach's Park, Clones, Co Monaghan.

Russell Pritchard / SPORTSFILE

2007

Jason Sherlock, Dublin, dodges Michael McGoldrick, Derry.
All-Ireland Senior Football Championship Quarter-Final,
Croke Park. Dublin survived a late Derry rally and held on to
win 0-18 to 0-15.

Pat Murphy / SPORTSFILE

2007

Kieran Donaghy, left, celebrates with team-mate Colm 'The Gooch' Cooper after scoring his second and his side's third goal against Cork. Kerry won by ten points in only the second final in the GAA's history contested by two teams from the same province. All-Ireland Senior Football Championship Final, Croke Park.

Brian Lawless / SPORTSFILE

Wheeling away to the Hill with my partner in crime after scoring my second goal against Cork in Croke Park is about as good as it gets. There was big pressure on that game for that Kerry team and we delivered once more and became the first team in eighteen years to hold on to the Sam Maguire.

Kieran Donaghy

2008

Fermanagh and Monaghan players scramble for the ball in midfield.

Ulster Senior Football Championship Quarter-Final, Brewster Park,

Enniskillen, Co. Fermanagh.

Oliver McVeigh / SPORTSFILE

Opposite: 2008

Conor Mortimer, Mayo, in action against Conor Gormley, Tyrone.

All-Ireland Senior Football Championship Qualifier, Round 3, Croke Park.

Matt Browne / SPORTSFILE

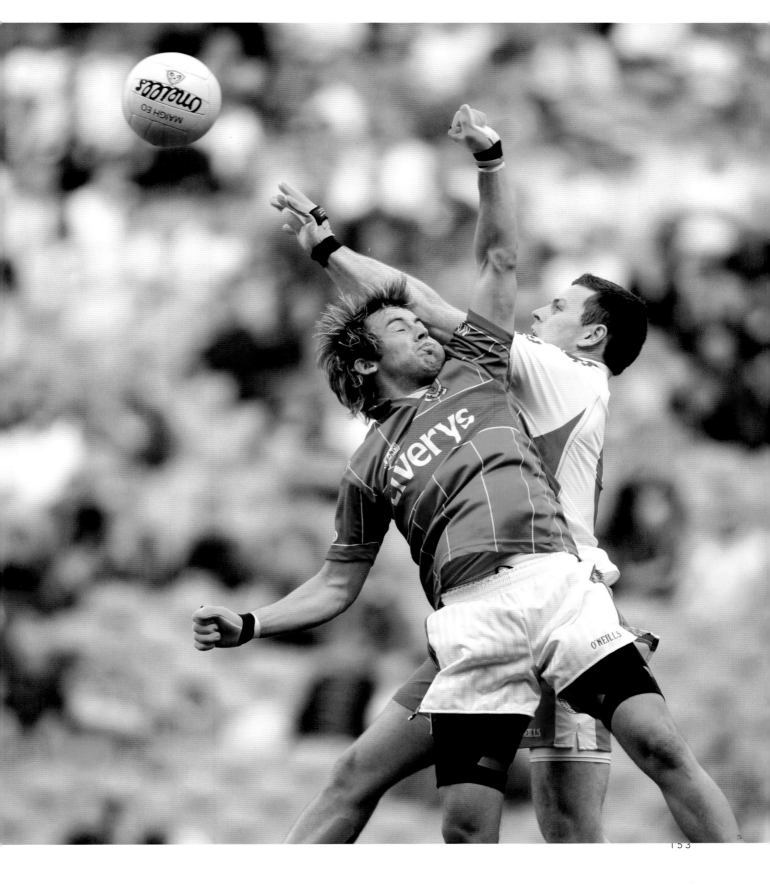

2008

Clash of the Titans: Sean Cavanagh, Tyrone, is tackled by Tom O'Sullivan, Kerry. All-Ireland Senior Football Championship Final, Croke Park. The two teams had won six titles between them in the previous seven years: 2000, 2004, 2006, 2007 (Kerry) and 2003, 2005 (Tyrone).

Ray McManus / SPORTSFILE

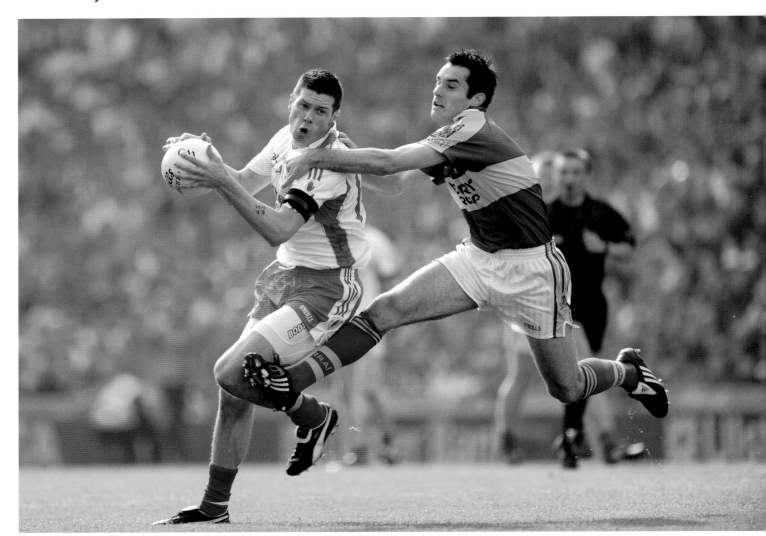

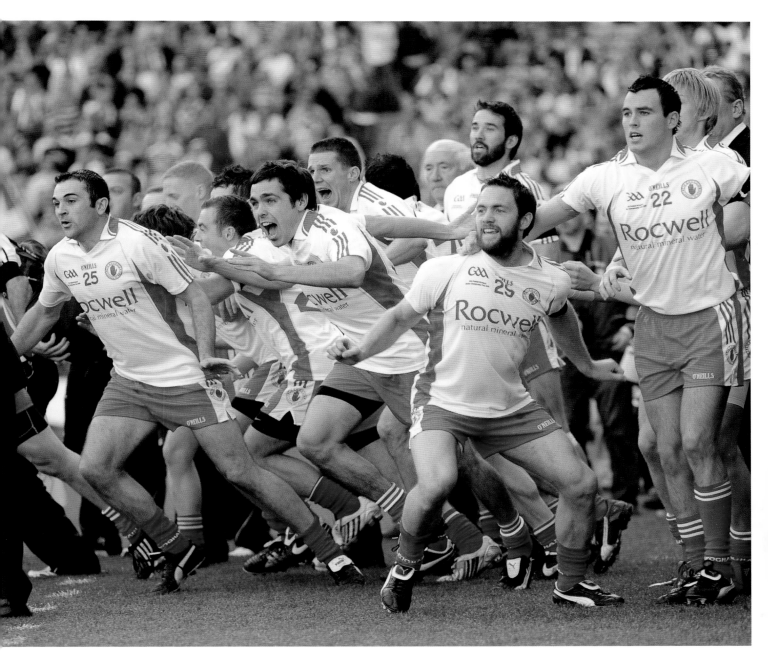

2008

Tyrone substitutes Paul Quinn, 32, Martin Penrose, 29 and Cathal McCarron, 22, celebrate victory at the final whistle. All-Ireland Senior Football Championship Final, Croke Park.

Brendan Moran / SPORTSFILE

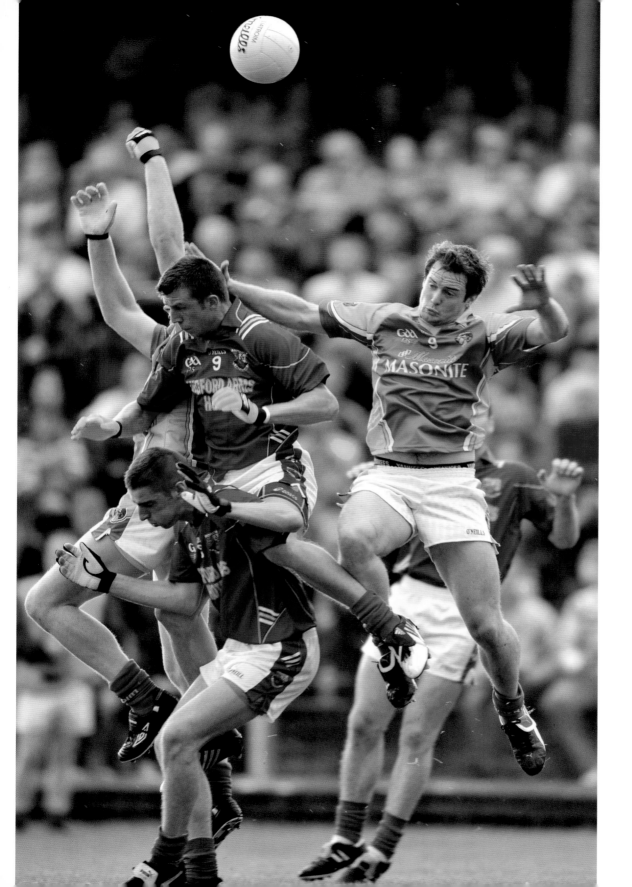

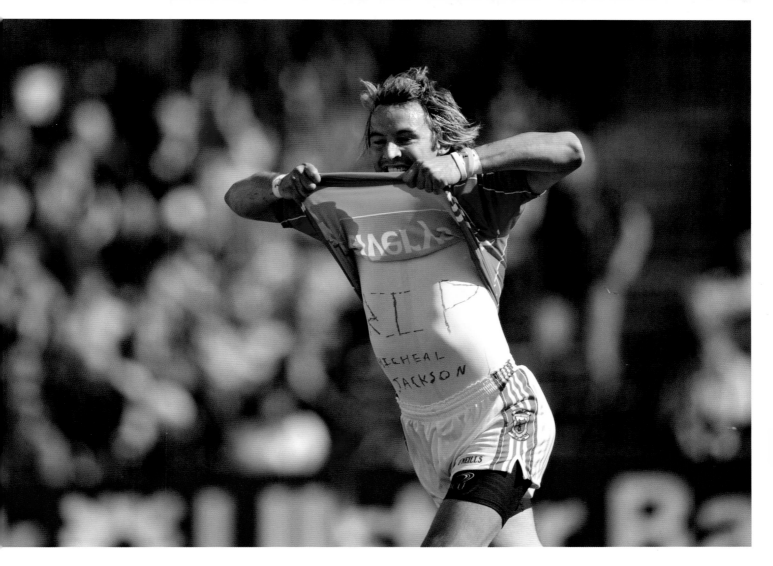

Opposite 2009

Shane Canning, 9, and Gary McCloskey, Leitrim, in action against Kevin Smith, 9, and Ger Dennigan, Longford. All-Ireland Senior Football Championship Qualifier, Round 1, Páirc Seán Mac Diarmada, Carrick-on-Shannon, Co. Leitrim.

David Maher / SPORTSFILE

Above 2009

Conor Mortimer celebrates the second Mayo goal by lifting his jersey to reveal his tribute to Michael Jackson. Connacht Senior Football Championship Final, Galway v Mayo, Pearse Stadium, Salthill, Galway.

Ray McManus / SPORTSFILE

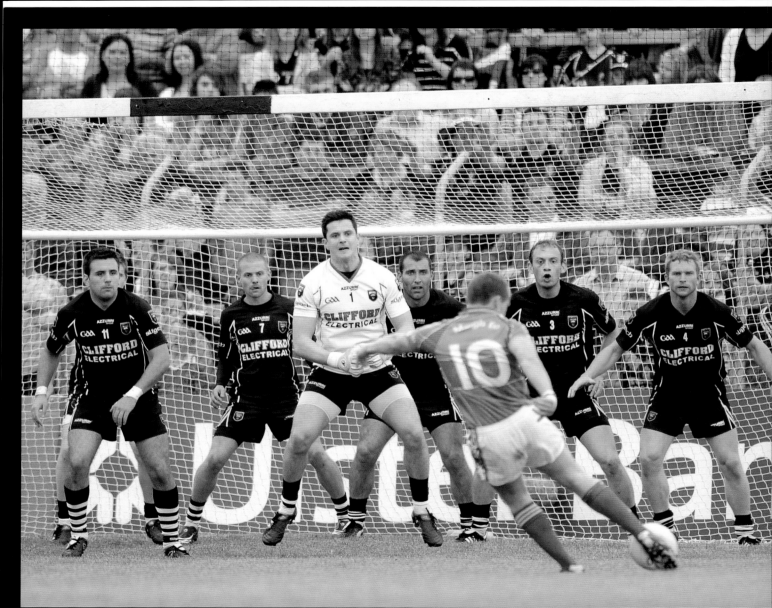

2010

Through the wall: Andy Moran, Mayo, tries to score a goal from a free in the closing minutes of the game. Connacht Senior Football Championship Quarter-Final, Sligo v Mayo, Markievicz Park, Sligo. Sligo, under Kevin Walsh, had a surprising 0-15 to 1-8 win over win over Mayo and made it as far as the 2010 Connacht final.

Ray Ryan / SPORTSFILE

2010s

2010

Joe Sheridan, Meath, beats Louth players, left to right, Paddy Keenan, Andy McDonnell, Dessie Finnegan and goalkeeper Neil Gallagher, on his way to scoring a late – and controversial – goal to win the Leinster title. Leinster Senior Football Championship Final, Croke Park.

David Maher / SPORTSFILE

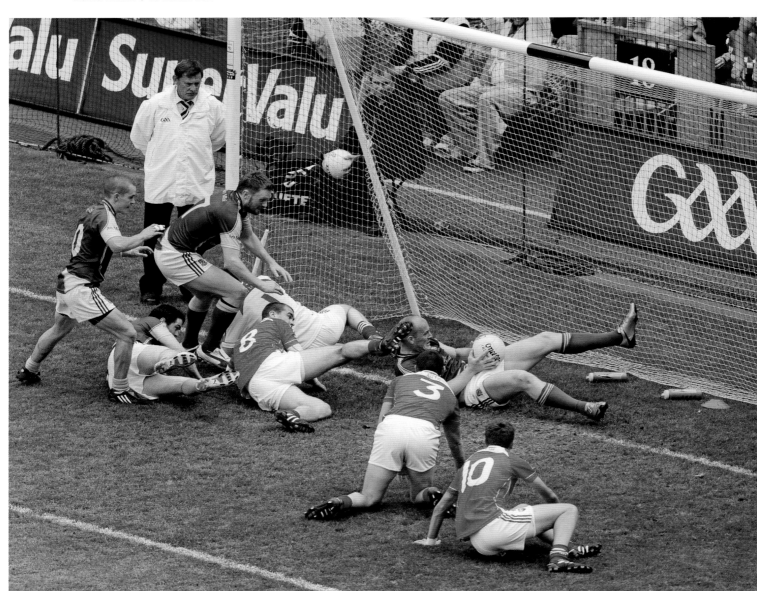

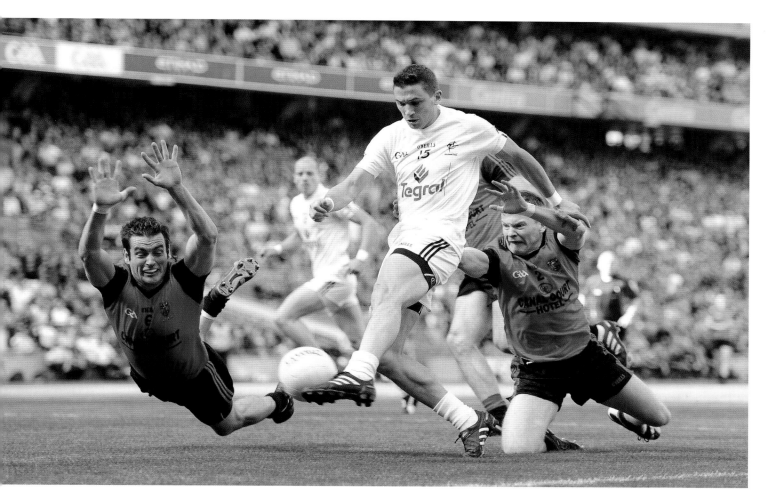

2010

Eamonn Callaghan, Kildare, in action against Daniel McCartan, right, and Kevin McKernan, Down. All-Ireland Senior Football Championship Semi-Final, Croke Park.

Paul Mohan / SPORTSFILE

This was the All-Ireland semi-final between Down and Kildare. Down won the game by 2 points beating Kildare 1-16 to 1-14. Eamonn Callaghan who features in the photograph scored 1-1 for Kildare that day. Down were subsequently beaten by Cork in the final by a point. The angle the picture is taken from is different from the normal position I would be in. I was a lot closer to the goal on a wider lens than normal, so you can actually see more of Croke Park in the background. I feel this adds a sense of atmosphere and occasion. I like the picture because of the timing. Everything came into place at the right time and it shows the efforts that the Down players put in that day. Kevin McKernan who features in the picture scored 3 points for Down on the day.

Paul Mohan, photographer

163

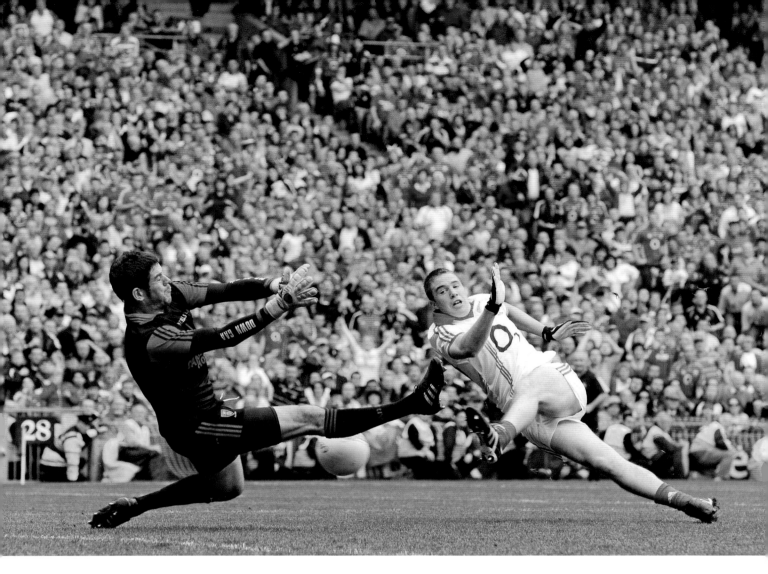

2010

Cork's Colm O'Neill has his shot stopped by Down goalkeeper Brendan McVeigh. The Rebels would go on a win this game by a single point on a score-line of 0-16 to 0-15. All-Ireland Senior Football Championship Final, Croke Park.

Brian Lawless / SPORTSFILE

2011

Oisín McConville, Crossmaglen Rangers, celebrates at the final whistle. McConville was a key member of the Crossmaglen Rangers team that won six All-Ireland Club titles between 1997 and 2012. All-Ireland Senior Club Championship Semi-Final, Kilmacud Crokes v Crossmaglen Rangers, Páirc Tailteann, Navan, Co. Meath.

Brian Lawless / SPORTSFILE

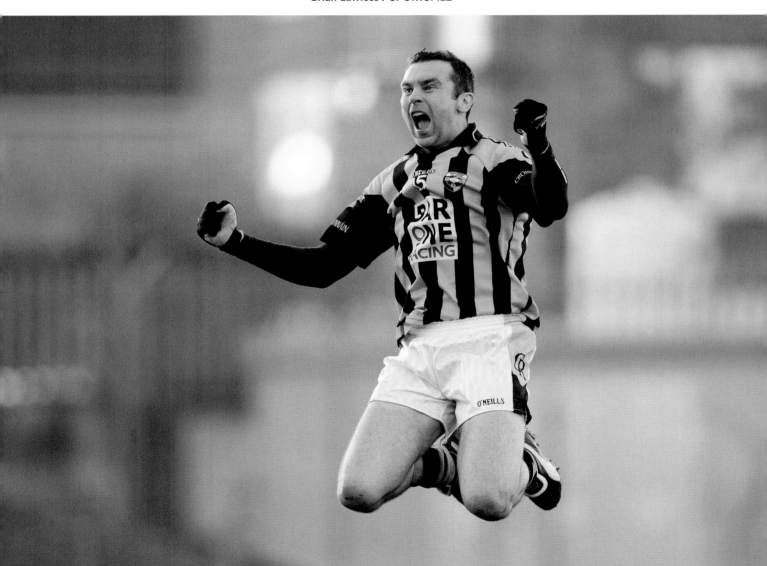

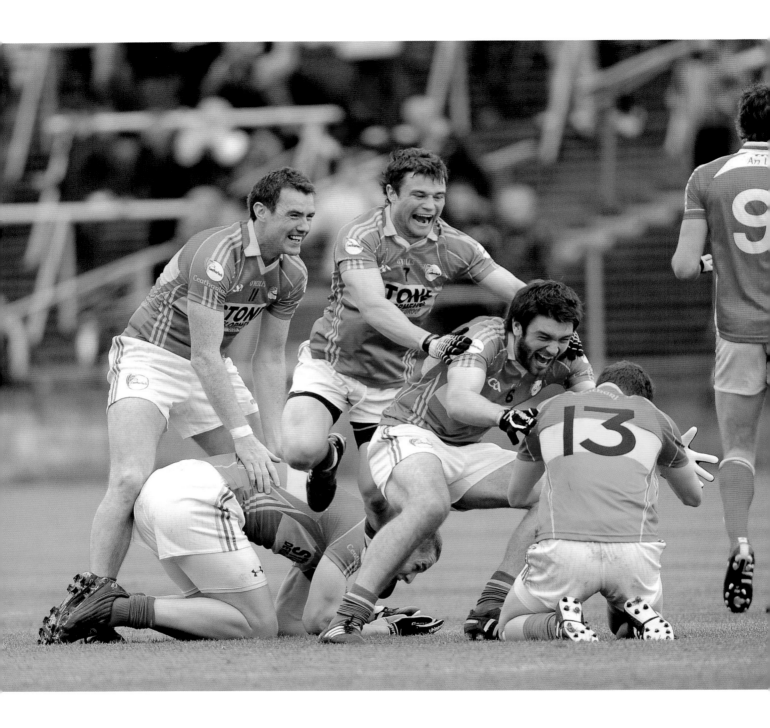

2011

Carlow players from left, Thomas Walsh, Brendan Murphy, Kieran Nolan, 7, Shane Redmond, 6, and Brian Murphy, 13, celebrate after the final whistle. Leinster Senior Football Championship Quarter-Final, O'Moore Park, Portlaoise, Co. Laois.

Matt Browne / SPORTSFILE

I remember the chanting from the Carlow supporters. Portlaoise was a great venue for the match. As a player I normally wouldn't take much notice of what's happening off the pitch but the chanting for Carlow that day was unbelievable and definitely helped to drive us over the line. It was like a cauldron out on the field. The heat of a close championship match is the most enjoyable part of the GAA for me – to be involved and come out on the right side was euphoric. A few days later I was back working in an office in Meath. Someone came in and the first point of conversation was still how much of an upset we had caused. Little did he know I was sitting a few desks over. To cause an impact like that was a great feeling. We had left a mark; caused a stir. It was uncharted territory for most of us on the panel, but we relished it. Unfortunately it didn't transform into results for the rest of the year. We lost heavily to Wexford in the Leinster Semi-Final before losing to Antrim by a point in the qualifiers. It was a disappointing end to a year with such a special day in it. But looking back now, I can remember that day in Portlaoise a lot better than either of those defeats.

Shane Redmond

2011

Shane McAnarney, Meath, in action against Mark Hehir, Galway. Meath left it until injury time to beat Galway by one point. All-Ireland Senior Football Championship Qualifier Round 2, Páirc Tailteann, Navan, Co. Meath.

Paul Mohan / SPORTSFILE

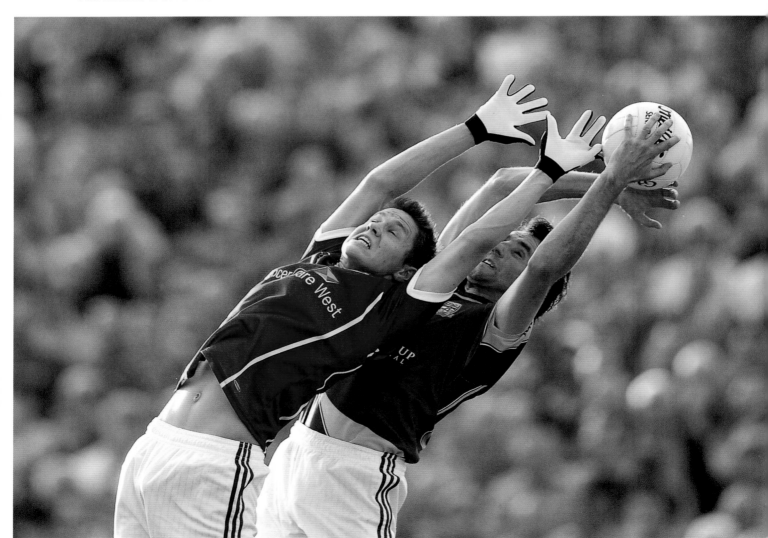

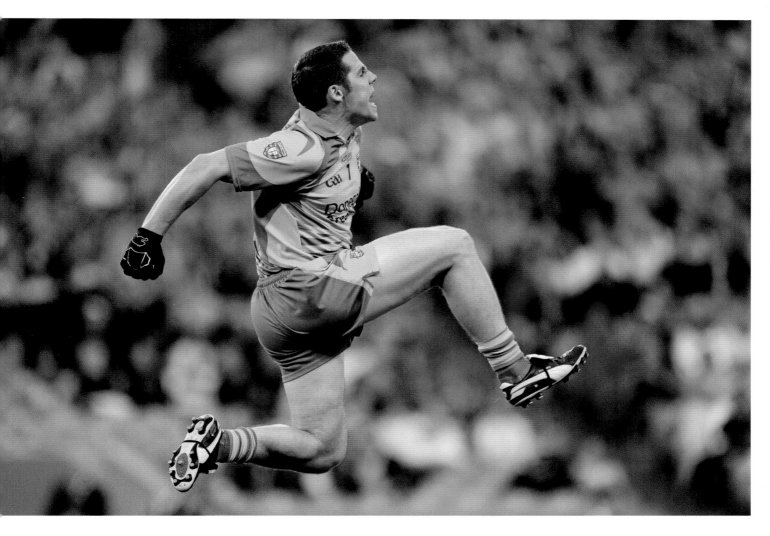

2011

Kevin Cassidy, Donegal, celebrates after scoring his side's winning point against Kildare. All-Ireland Senior Football Championship Quarter-Final, Croke Park.

Dáire Brennan / SPORTSFILE

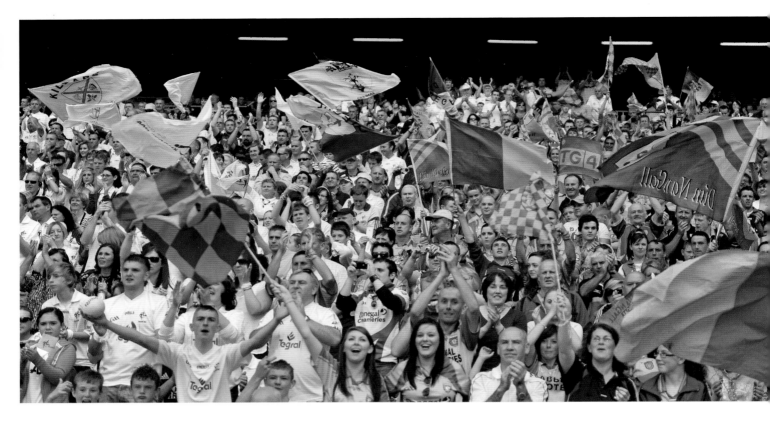

2011

Kildare and Donegal supporters cheer on their team during the pre-match parade. Senior Football Championship Quarter-Final, Croke Park.

Dáire Brennan / SPORTSFILE

2011

Martin Penrose, Tyrone, in action against Rory O'Carroll, left, and James McCarthy, Dublin. All-Ireland Senior Football Championship Quarter-Final, Croke Park.

Stephen McCarthy / SPORTSFILE

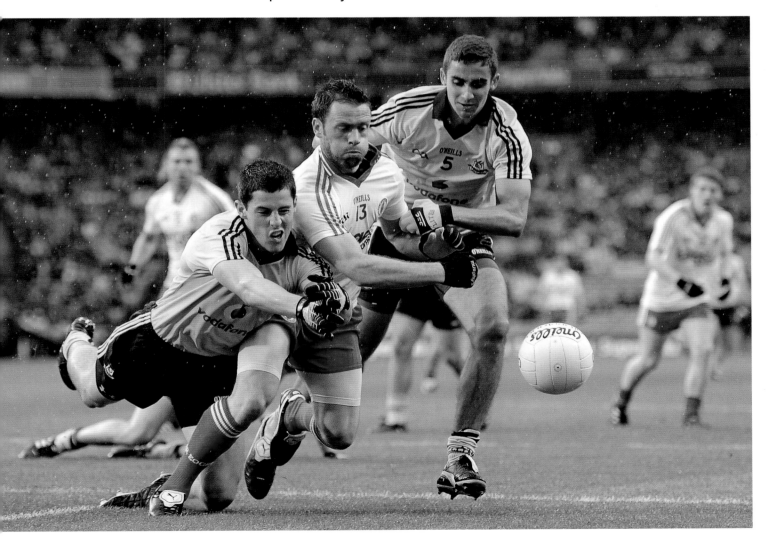

2011

Dublin goalkeeper Stephen Cluxton kicks the winning point in extra time from a free kick. All-Ireland Senior Football Championship Final, Croke Park.

Brian Lawless / SPORTSFILE

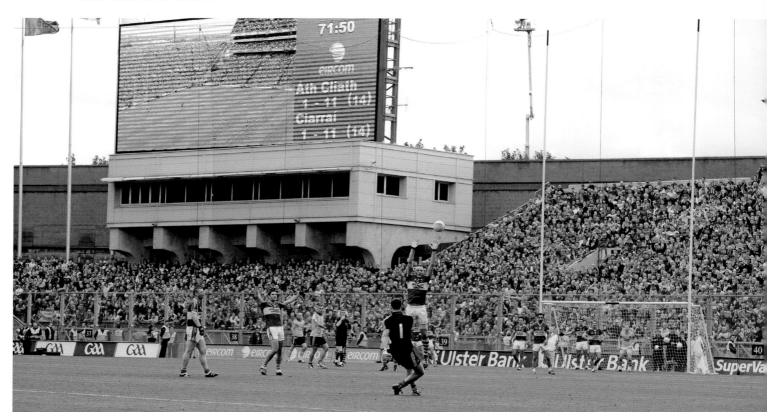

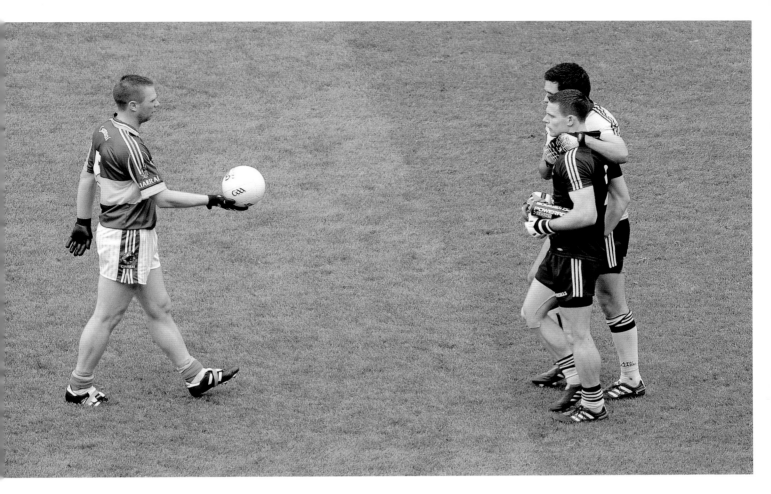

2011

Tomas Ó Sé, Kerry, offers the match ball to Stephen Cluxton, Dublin.

All-Ireland Senior Football Championship Final, Croke Park.

Dáire Brennan / SPORTSFILE

Tomás Ó Sé had just lost the All-Ireland Final by 1 point. He was obviously incredibly disappointed, but he showed his graciousness and class by seeking out Dublin match-winner Stephen Cluxton after the game to present him with the match ball. Cluxton had scored the free in injury time which famously won Dublin the All-Ireland for the first time in sixteen years. Cluxton accepted the ball and immediately kicked it into the Hogan Stand. He wasn't interested in celebrating with team-mate Cian O'Sullivan, and he immediately ran back into the dressing room before the presentation. I like the shot, because it shows the class of Tomás Ó Sé and it epitomises the ethos and all that is good about the GAA and also because it was a special day for all Dublin supporters, myself included.

Dáire Brennan, photographer

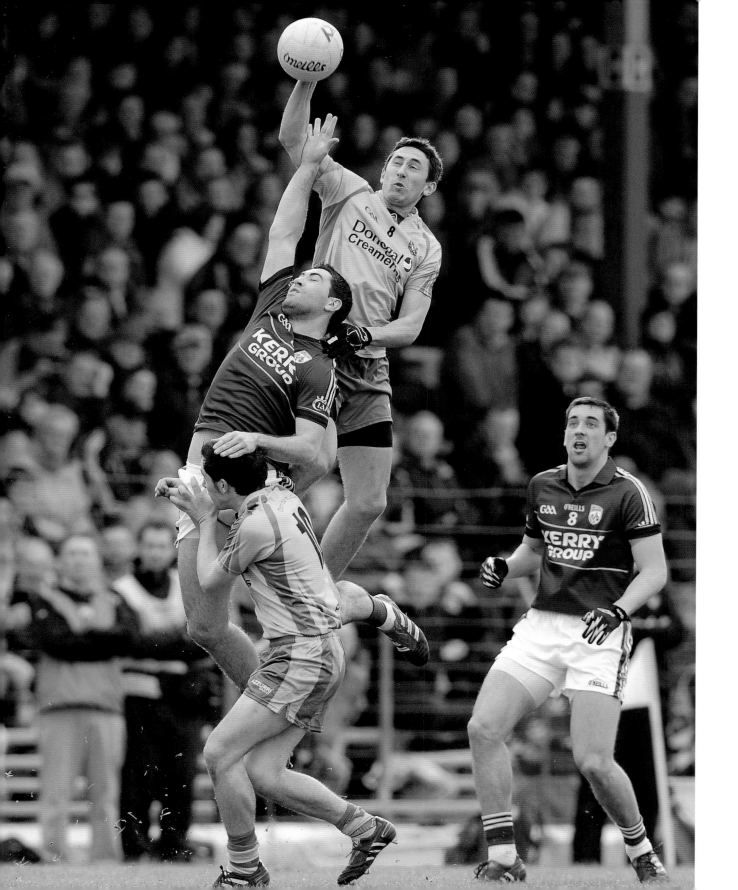

2012

Rory Kavanagh, Donegal, and Bryan Sheehan, Kerry, leap for the ball. Allianz Football League Division 1, Round 4, Fitzgerald Stadium, Killarney, Co. Kerry.

Diarmuid Greene / SPORTSFILE

2012

Padraig Clancy, Laois, is tackled by Barry Gilleran, Longford. Leinster Senior Football Championship, Pearse Park, Longford.

Matt Browne / SPORTSFILE

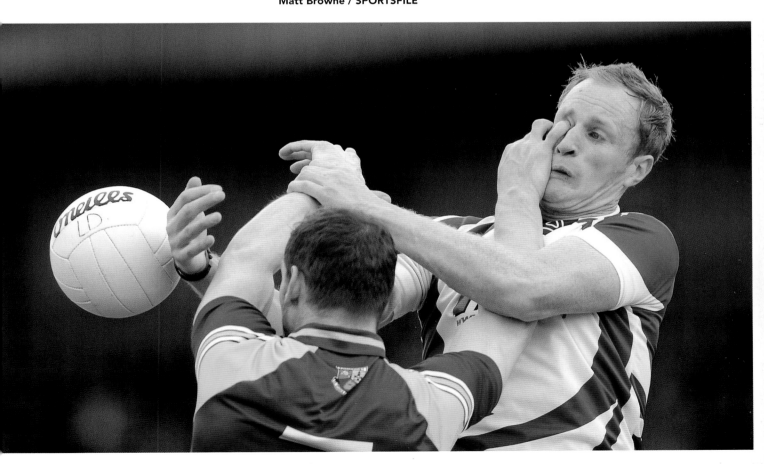

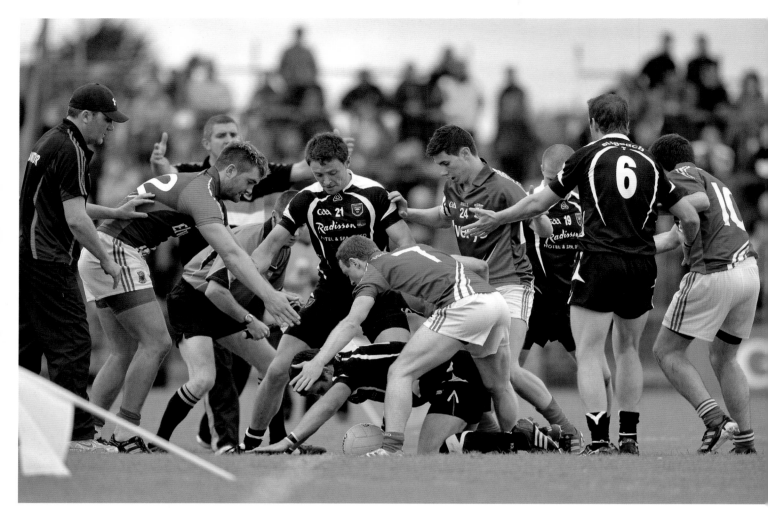

2012

Brendan Egan, centre, Sligo, with support from team-mates Eugene
Mullen, left, Johnny Davey, 19, and Mark Quinn, right, tries to gather
the ball up despite the challenges from Aidan O'Shea, left, Colm
Boyle, centre, and Alan Freeman, right, Mayo. Connacht Senior Foot-
ball Championship Final, Dr Hyde Park, Roscommon.

Barry Cregg / SPORTSFILE

2013

Ciaran McCallion, London, celebrates his side's first championship-game win in thirty-six years. London went on to the Connacht Final; they lost to Mayo, but went on to play in Croke Park in a round 4 qualifier, giving them the longest championship run in London's history. Senior Football Championship, Quarter-Final, Emerald Park, Ruislip, London, England.

Stephen McCarthy / SPORTSFILE

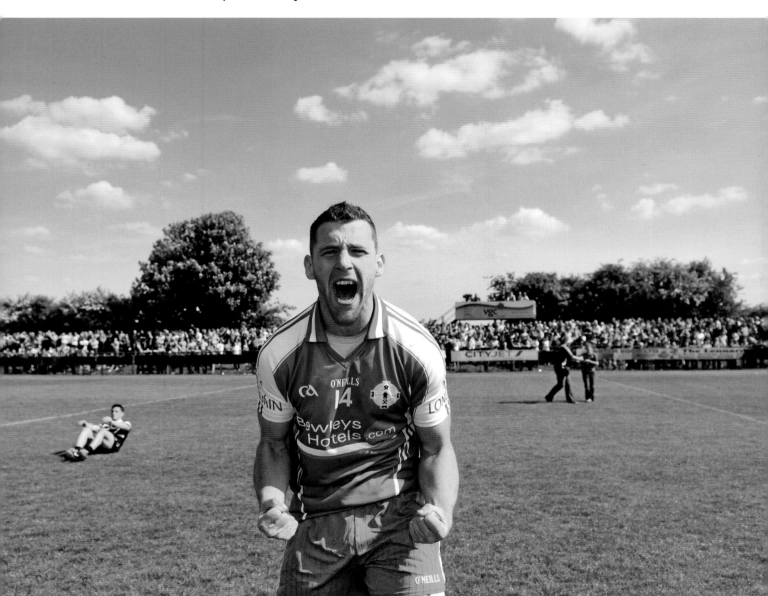

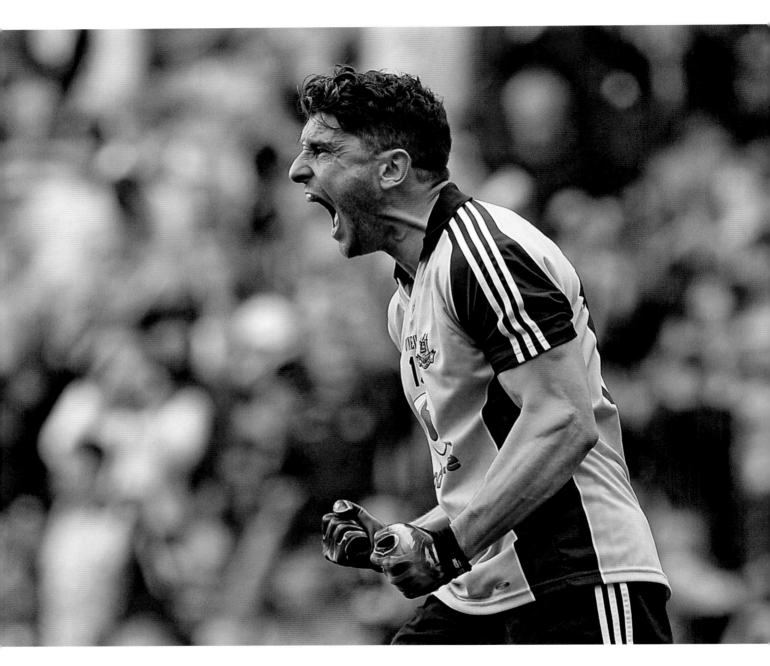

2013

Bernard Brogan, Dublin, celebrates after scoring his side's second goal. Leinster Senior Football Championship, Semi-Final, Kildare v Dublin, Croke Park.

David Maher / SPORTSFILE

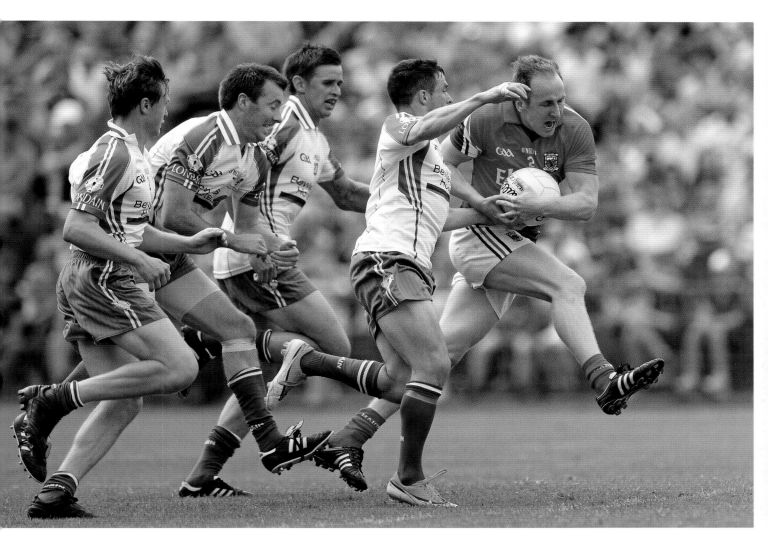

2013

Tom Cunniffe, Mayo, in action against London players, from left, Philip Butler, Stephen Curran, Cathal Óg Greene and David McGreevy. Connacht Senior Football Championship Final, Elverys MacHale Park, Castlebar, Co. Mayo.

Stephen McCarthy / SPORTSFILE

2013

Referee Joe McQuillan keeps a close eye as Donegal players Michael Murphy and Neil Gallagher are outnumbered by Mayo's Donal Vaughan, 6, Lee Keegan, 5, Séamus O'Shea and Colm Boyle during the second half. 2013 was the first year Hawk-Eye was used in Croke Park. All-Ireland Senior Football Championship, Quarter-Final, Croke Park.

Ray McManus / SPORTSFILE

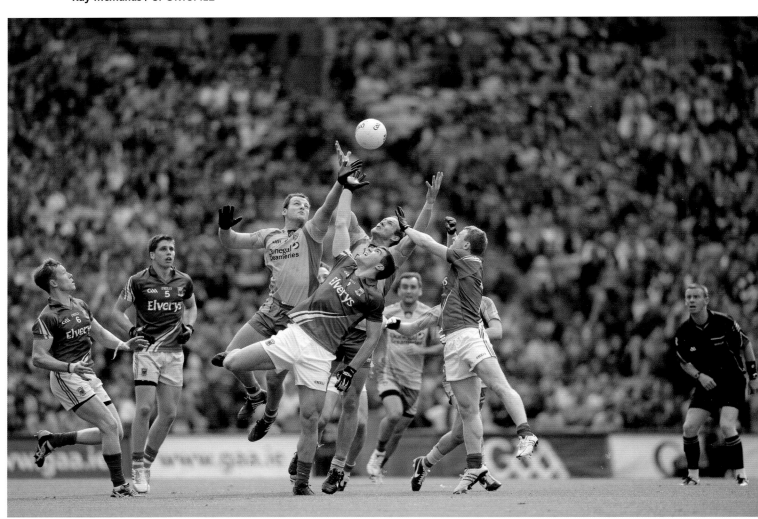

2013

Peter Harte, Tyrone, and Tom Cunniffe, Mayo, clash shoulder to shoulder in the fifth minute. Tyrone's Peter Harte was substituted following the heavy hit. All-Ireland Senior Football Championship Semi-Final, Croke Park.

Ray McManus / SPORTSFILE

2013

In the spotlight: Denis Bastick, Dublin, and
Aidan O'Shea, Mayo. All-Ireland Senior Football
Championship Final, Croke Park.

Dáire Brennan / SPORTSFILE

2013

Jonny Cooper, Dublin, consoles Mayo goalkeeper and former DCU teammate Rob Hennelly at the end of the game, after Dublin beat Mayo 2-12 to 1-14. All-Ireland Senior Football Championship Final, Croke Park.

David Maher / SPORTSFILE

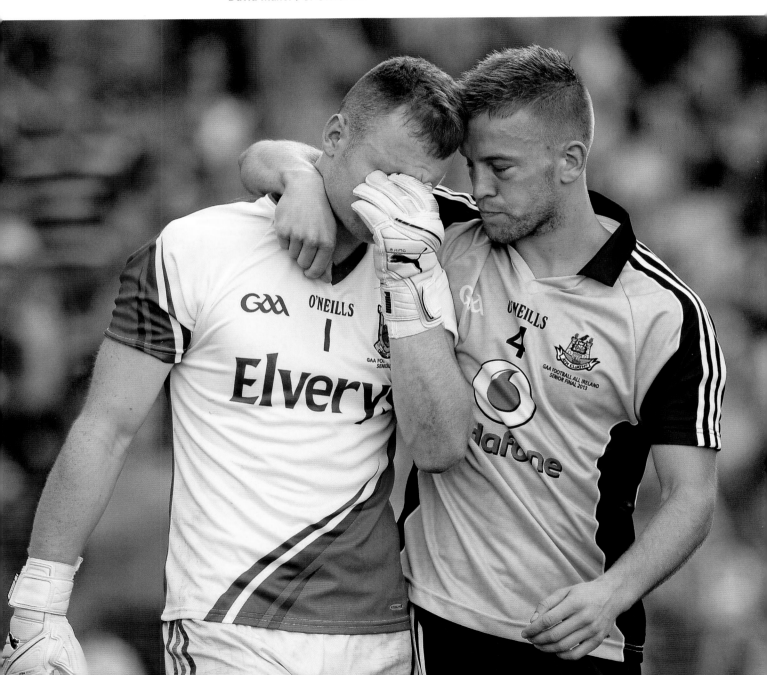

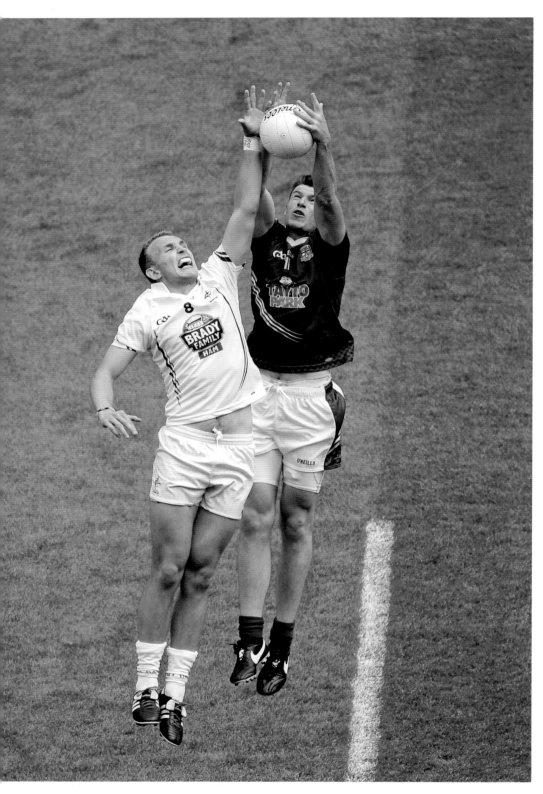

2014

Shane O'Rourke, Meath, and Tommy Moolick, Kildare. Leinster Senior Football Championship Semi-Final, Croke Park. Meath progressed to the Leinster final where they lost to 2013 All-Ireland champions, Dublin.

Dáire Brennan / SPORTSFILE

2014

Bryan Sheehan, Kerry, in action against Aidan Walsh, Cork. Munster Senior Football Championship Final, Páirc Uí Chaoimh, Cork.

Diarmuid Greene / SPORTSFILE

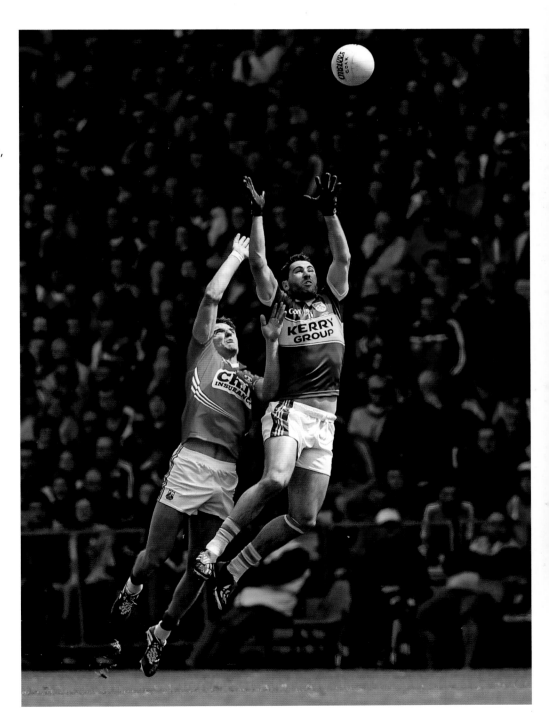

2014

James O'Donoghue, Kerry, celebrates after scoring his side's first goal against Galway. O'Donoghue would finish the year with a total of 4-24, his first All-Ireland, and the All-Stars Footballer of the Year Award. All-Ireland Senior Football Championship, Quarter-Final, Croke Park.

Brendan Moran / SPORTSFILE

2014

Damien Carroll, Meath, is surrounded by Mark Shields, Stefan Campbell, Stephen Harold and Andy Mallon, Armagh. All-Ireland Senior Football Championship, Round 4B, Croke Park.

Oliver McVeigh / SPORTSFILE

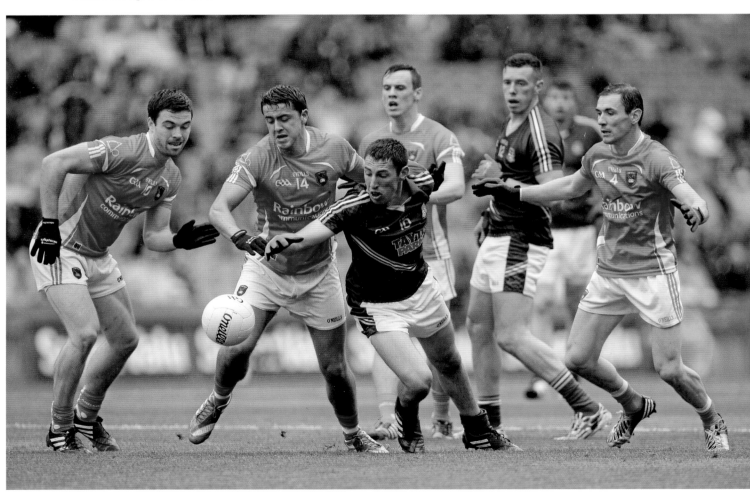

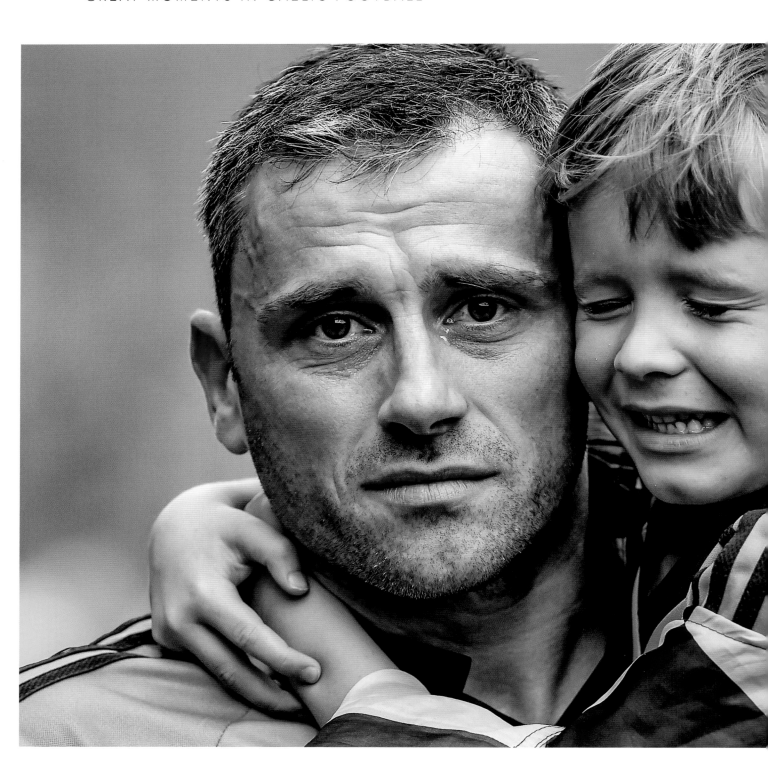

2014

A tearful Alan Brogan of Dublin leaves the pitch with his son Jamie after defeat by Donegal. All Ireland Senior Football Championship Semi-Final, Croke Park.

Brendan Moran / SPORTSFILE

This photo is a reminder to me of the ups and downs of sport, the emotion of losing an All-Ireland Semi-Final was heightened by my son, Jamie. At the time this may have been my last appearance in Croke Park playing with Dublin, thankfully we got another go the following year and managed to win the All Ireland. The photo really captures the essence of my mood at that time and will be great to look back on in years to come.

Alan Brogan

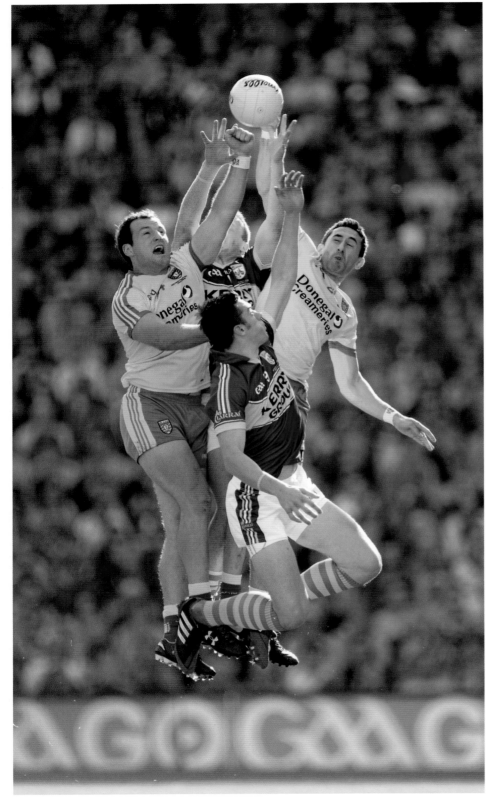

2014

Michael Murphy, left, and Rory
Kavanagh, Donegal, contest
a high ball with Kerry's David
Moran and Johnny Buckley,
behind. All Ireland Senior Football
Championship Final, Croke Park.

Pat Murphy / SPORTSFILE

2014

The Kerry squad celebrate with the Sam Maguire cup after the game. All Ireland Senior Football Championship Final, Kerry v Donegal. Croke Park. Both sides had defeated the previous year's finalists, Dublin and Mayo, in their semi-finals to set up this final match between 'the two great football outposts of the west-coast extremities'.

Ramsey Cardy / SPORTSFILE

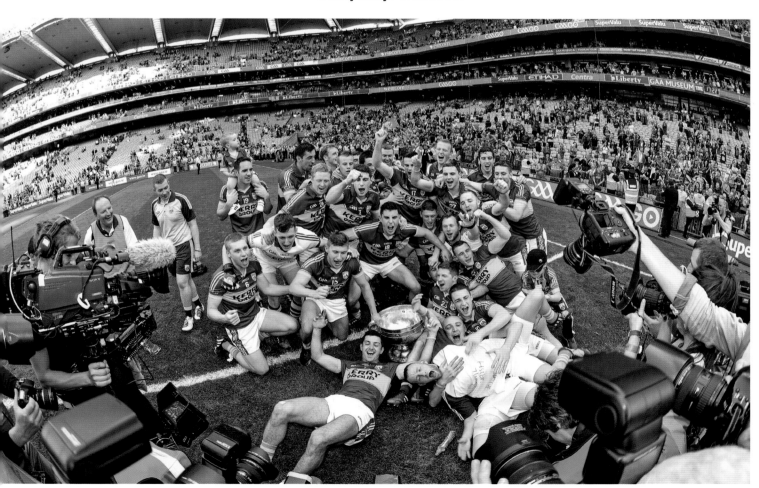

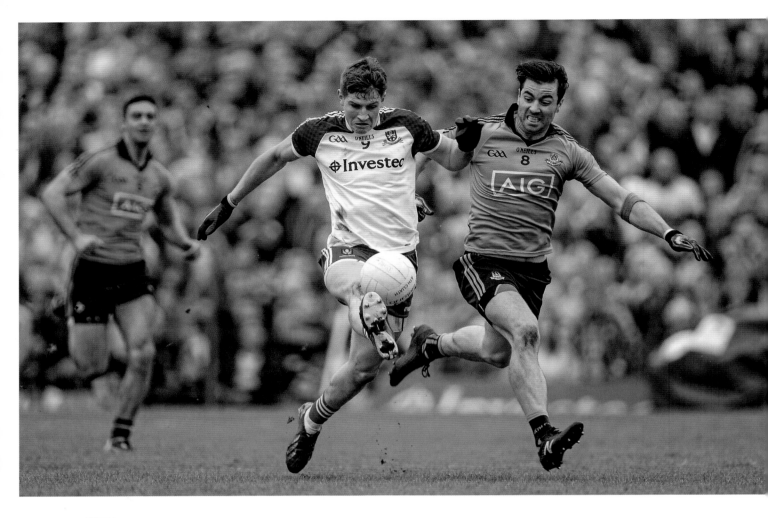

2015

Darren Hughes, Monaghan, solos the ball as he attempts to get way from the challenge of Michael Darragh Macauley, Dublin. Allianz Football League, Division 1, Round 7. St Tiernach's Park, Clones, Co. Monaghan.

Brendan Moran / SPORTSFILE

2015

Gary Brennan, Clare, slips past Alan O'Connor, left, and Kevin O'Driscoll, Cork. Munster Senior Football Championship Semi-Final. Páirc Uí Rinn, Cork.

Eoin Noonan / SPORTSFILE

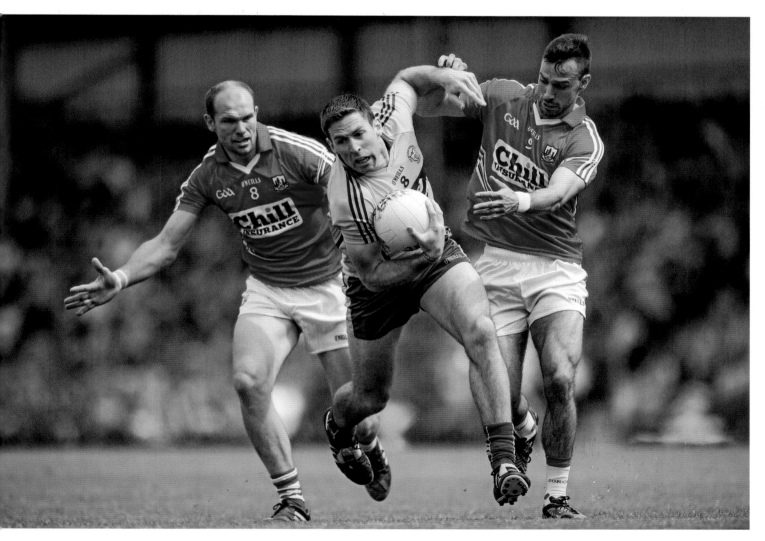

2015

Westmeath's Ray Connellan celebrates following his side's victory – Westmeath played a storming second half, giving them their first ever championship win over Meath. Leinster Senior Football Championship Semi-Final, Croke Park.

Ramsey Cardy / SPORTSFILE

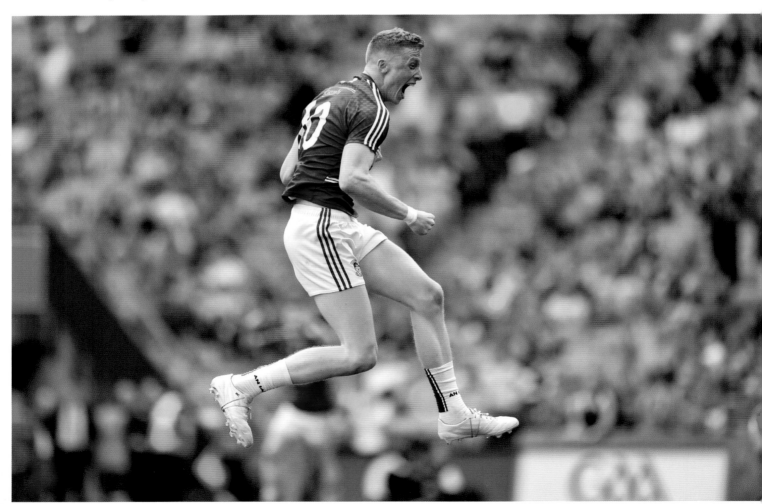

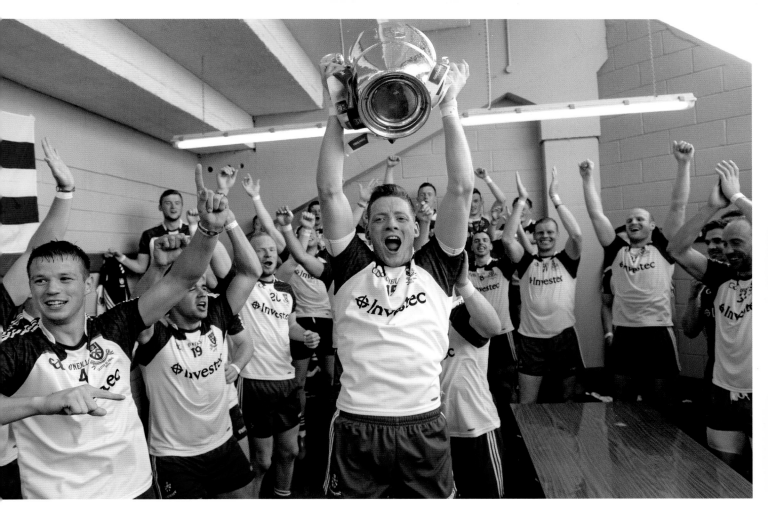

2015

Conor McManus, Monaghan celebrates in the changing room with the Anglo-Celt cup. Ulster Senior Football Championship Final, Donegal v Monaghan, St Tiernach's Park, Clones, Co. Monaghan.

Oliver McVeigh / SPORTSFILE

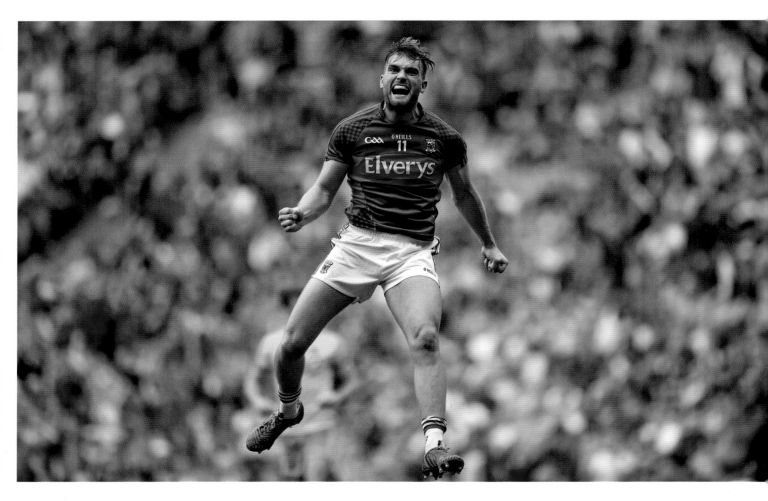

2015

Aidan O'Shea, Mayo, celebrates after scoring his side's first goal. All-Ireland Senior Football Championship Quarter-Final. Donegal v Mayo, Croke Park.

Stephen McCarthy / SPORTSFILE

2015

Paul Geaney, Kerry, in action against Stephen Cluxton, left, and
Rory O'Carroll, Dublin. All Ireland Senior Football Championship
Final, Dublin v Kerry, Croke Park.

Ramsey Cardy / SPORTSFILE

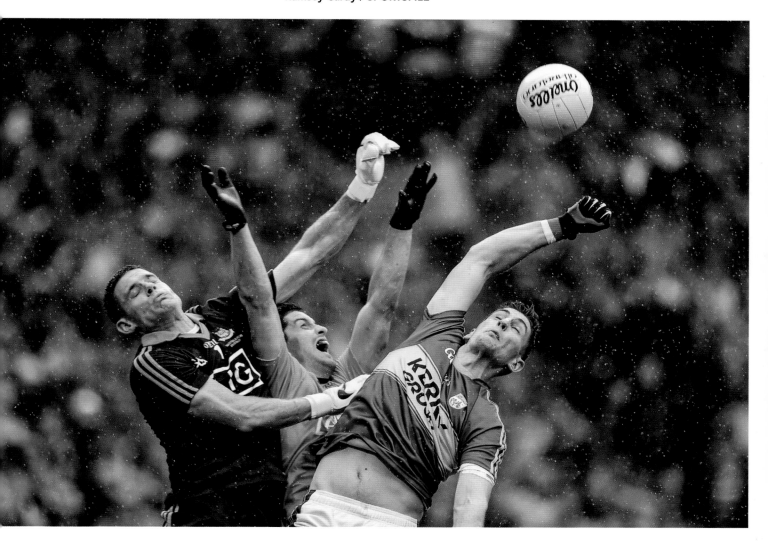

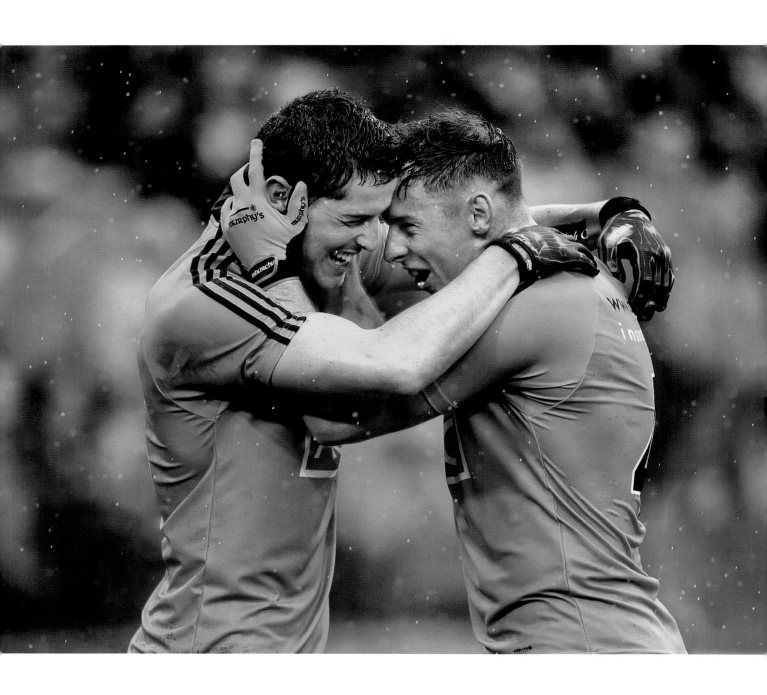

2015

Dublin's Rory O'Carroll, left, and Philly McMahon
celebrate at the final whistle. All Ireland Senior Football
Championship Final, Dublin v Kerry, Croke Park.

Ramsey Cardy / SPORTSFILE

This image was taken after Dublin won the football final on a wet and miserable day in
Croke Park. The picture shows two friends and teammates embracing their success over
Kerry when they took back the Sam Maguire Cup. It was very difficult to capture the true
atmosphere, celebration and relief of the Dublin team that day, but this picture comes
as close as I could. It is quite clear how hard they struggled through the wind and the
rain and Rory and Philly, weather-beaten and exhausted, were some of the happiest men
I've ever seen, as their team once again brought the cup home. The fans were out in
full force. It was an amazing day. As it was my first *A Season of Sundays* cover, it was a
special image for me to take. I will always remember that day, both because how horrible
the weather was -- I was soaked through when I got home – and because I captured a
great moment in Gaelic football history.

Ramsey Cardy, photographer

THE HEART & SOUL OF
KERRY
FOOTBALL

WEESHIE FOGARTY

In Kerry, Gaelic football is made from passion and magic, and
Weeshie Fogarty – former player and referee, now an analyst and
presenter of Radio Kerry's *Terrace Talk* – knows all about it. In *The
Heart & Soul of Kerry Football* he interviews the sport's leading
figures, pays tribute to its great players and lifts the lid on its
unforgettable occasions, while tracing Kerry's fortunes through
good times and bad. *The Heart & Soul of Kerry Football* reflects
its author's big personality and love of life – it's an extraordinarily
vivid and entertaining read.

**'Promises to be one of the finest insights into a GAA culture
to ever grace the bookshelves'**
The42.ie

Winner of the Boylesports Irish Sports Book of the Year. On 19 September 1982, Kerry ran out in Croke Park chasing their fifth title in a row; their Offaly opponents had dragged themselves up from their lowest ebb and now stood on the cusp of glorious reward. The outcome was an All-Ireland football final that changed lives and dramatically altered the course of football history. *Kings of September* is an epic story of triumph and loss, joy and tragedy, a story of two teams that illuminated a grim period in Irish life – and enthralled a nation.

'A beautiful book and a brilliant piece of journalism.'
The Sunday Times

Winner of the GAA McNamee Award for Best GAA Publication. Michael Foley recounts the story of Bloody Sunday 1920 and the shooting in Croke Park that changed history forever. He tells for the first time the stories of those killed, of the police and military personnel, and of the families left shattered in the aftermath, all against the backdrop of a fierce conflict that stretched from the streets of Dublin and the hedgerows of Tipperary to the halls of Westminster.

'A sports book, a history book, a thriller . . .
The best sports book of 2014.'
The Irish Times